Hollis Frampton
(nostalgia)

Rachel Moore

Afterall Books Editors
Charles Esche and Mark Lewis

One Work Series Editor
Mark Lewis

Contributing Editor
Jan Verwoert

Managing Editor
Caroline Woodley

One Work is a unique series of books published by Afterall, based at Central Saint Martins College of Art and Design in London. Each book presents a single work of art considered in detail by a single author. The focus of the series is on contemporary art and its aim is to provoke debate about significant moments in art's recent development.

Over the course of more than 100 books, a variety of important works will be presented in a meticulous and generous manner by writers who believe passionately in the originality and significance of the works about which they have chosen to write. Each book contains a comprehensive and detailed formal description of the work, followed by a critical mapping of the aesthetic and cultural context in which it was made and has gone on to shape. The changing presentation and reception of the work throughout its existence is also discussed and each writer stakes a claim on the influence 'their' work has on the making and understanding of other works of art.

The books insist that a single contemporary work of art (in all of its different manifestations) can, through a unique and radical aesthetic articulation or invention, affect our understanding of art in general. More than that, these books suggest that a single work of art can literally transform, however modestly, the way we look at and understand the world. In this sense the *One Work* series, while by no means exhaustive, will eventually become a veritable library of works of art that have made a difference.

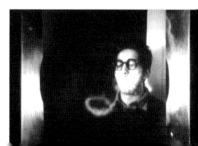

First published in 2006
by Afterall Books

Afterall
Central Saint Martins
College of Art and Design
University of the Arts London
107—109 Charing Cross Road
London WC2H ODU
www.afterall.org

ISBN Paperback: 1-84638-001-4
ISBN Cloth: 1-84638-018-9

Distribution by The MIT Press, Cambridge,
Massachusetts and London, England
www.mitpress.mit.edu

Art Direction and Typeface Design
A2/SW/HK

Printed and bound by
Die Keure, Belgium

The soundtrack of *(nostalgia)* is republished
here by kind permission of Bruce Jenkins
co-editor with Susan Krane of *Hollis Frampton:
Recollections/Recreations* (Cambridge:
The MIT Press, 1984)

Images courtesy of Frampton Estate/LUX
Photographs by Jenny Nightingale from
a newly restored print of *(nostalgia)*
courtesy LUX

Hollis Frampton
(nostalgia)

Rachel Moore

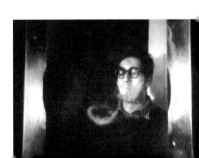

Invaluable access was provided by Charles Silver at MoMA, Robert Haller at Anthology Film Archives and the Museum of Modern Art Archives, New York. Special thanks to LUX in London and to Ben Cook and Mike Sperlinger in particular for their enthusiasm as well as their practical support, at all stages essential to this project. Acknowledgments — as Hollis Frampton wryly pointed out in his own — conveniently dispatch debt. But I would like to continue to owe Allen S. Weiss for introducing me to *(nostalgia)*, Bruce Grant for his comments on the manuscript at a crucial stage and who, along with Janet Harbord and Laura Mulvey aided the work of sifting through pasts, sustaining the present and clearing the way for a future. Also thanks to the John Simon Guggenheim Foundation for its support.

Rachel Moore is Lecturer in International Media for the Media and Communications Department at Goldsmiths, University of London. She is the author of *Savage Theory: Cinema as Modern Magic* (Durham: Duke University Press, 2000) and is currently undertaking research on 'The Film Archive of Natural-History', supported by the John Simon Guggenheim Foundation.

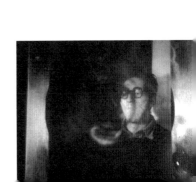

*In Greek the word means 'the wounds of returning'. Nostalgia
is not an emotion that is entertained; it is sustained. When
Ulysses comes home, nostalgia is the lumps he takes, not
the tremulous pleasures he derives from being home again.*[1]
— Hollis Frampton

*Men are by nature tilers and inclined to every calling, save
that of abiding at home.*[2]
— Blaise Pascal

In 1971 Hollis Frampton made a film that he called
(nostalgia) which records some of his experiences as
a photographer in the early 1960s. The film charts
his photographic career from 'the first photograph
I ever made with the direct intention of making art'
to its end, with the penultimate sentence, 'I think
I shall never dare to make another photograph again'.
Representing some seven years of one artist's career
in downtown New York City, the film is hardly epic
in either its temporal or spatial reach. The action is
confined to a hotplate on which photographs lie and
then proceed to combust. The narration is a series of
musings about the photographs. Despite such confine-
ment the film nonetheless takes us on a trip of sorts,
from past to present, from silence to language and from
photography to film. Like an odyssey, this trip is not
a straight run. For a good portion of the ride, the film
ferries between temporal registers, between images
and language, between the still and the moving image.
What emerges from these meanderings is a direct
engagement with consciousness itself as the viewer
gets caught in the grip of past, present and future time.

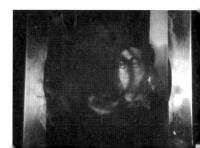

I first saw *(nostalgia)* in 1989, some four years after
the filmmaker's death from lung cancer, aged 48.
Though I can't quite recall the moment, I do remember
that watching it was like discovering that you know
how to read, or some revelation of that order. The film
itself is simple enough. It is monochrome, made of
thirteen 100-foot 16mm rolls that clearly display
their image at normal speed (just short of 3 minutes)
and runs for approximately 36 minutes in all. In
twelve of the thirteen segments a photograph appears
on the screen in silence for about twenty seconds, which
is just enough time to begin to make sense of it. The
photograph is on an electric burner, the sort you might
find in an artist's studio or a scientist's laboratory.
A half-interested male voice begins to account for the
photograph in the first person, telling us the facts about
when and where it was taken. As the narration begins
to elaborate on the possible significance of the photo-
graph, the heat from the coil penetrates the image and
it begins to burn. Shoots of flame and puffs of smoke
accompany the narration on screen while the voice-over
continues. The narration is a little confusing because
the things described in the photographs do not seem
to be there. It is difficult to tell though, because little
is left of the photograph at this point. The anecdote
winds to a close, the burning ends, and the carbon
flutters weakly over the hot coil in silence. This silence,
accompanied by the spent image, lasts quite a while,
almost as long as the storytelling itself. The next photo-
graph you see bears a resemblance to the description
you've just heard, but you are hearing yet another
story, so you forget all about the story that came before.

It gradually becomes clear that the photographs are narrated not by their own story, but by the story of the photograph yet to come. This simple procedure repeats until the film's end, yet, as it plods merrily along, it confronts us with everything that we know and feel about the cinema.

Early film projectionists used to play a kind of trick by beginning a film show with the image projected still and then slowly cranking the film into motion. By so animating the still, they appeared to release the movement that had been dormant in that single frame; they brought it, as the saying goes, to life. Along with the sheer wonder at the change from stillness to motion, a number of elemental shifts emerge in the movement from photography to film. The ability to take hold of the image, to contemplate it alone, endlessly, to see it in the light, trade off for the risk, contingency and sheer plasticity of time this nerve-wracking medium propels. *(nostalgia)* not only makes photographs move, it adds language to the picture. That the language does not quite fit, that the photographs are burning up and there is hardly time to contemplate the film calmly only heightens the sorts of tensions that inhabit film viewing in general. For once images start to move, the prospect that language cannot contain them threatens any stolid faith in total comprehension. Photographic reproduction directly transfers a thing to an image with light and shadow; it is as primitive and stable as a clay mould. A moving picture's gelatine emulsion, however, is made of animal bones. It decays.

Cinema, which can neither be touched, smelt nor even seen in the light of day, holds yet another paradox of stability and fragility: time. As surely as night follows day, time runs on in a measured fashion, in this case at twenty-four frames per second. The frames, however, are still pictures, and like fractions of time themselves, we never see them as such. In *(nostalgia)* it is only with the burning of the photograph that we perceive movement. That a film about nostalgia should be structured by fire, the unruliest of the elements, not only makes sport of the label 'structural film' with which Frampton was burdened, it replicates both the urgency and the decay that makes getting a grip on the passage of time so fraught.

My interest in this film, however, is not animated by a structural investigation of film's formal properties, but by nostalgia itself. The question is put to us, time and again whether any manner of representation can answer the demands of history; how can the weight of the past signify productively in the present? Key to this question is the part words, on the one hand, and images, on the other, play in our conjuring, reconfiguring, re-burying or re-enlivening of the past. Nostalgia is much maligned as a mode of experiencing the past in the present, yet, like it or not, it abides as the pre-eminent way in which we think about history. *(nostalgia)* is not only a microscopic investigation of the endless horrors and pleasures contained by an instant in time, but also an enlarge- ment of nostalgia to its full power. For while nostalgia is by definition painful, its burning impulse is utopian.

As Frampton rephrased the adage, 'a picture is worth some large but finite amount of words'.[3] A film's equivalent word count, by contrast, is infinite. Frampton was amongst those who saw film as a model of consciousness itself: 'If it is customary to say that film is young among the arts,' he stated, 'it is more responsible to notice that film is the first of the arts that has its roots in consciousness as we know it.' In a question-and-answer session at the Museum of Modern Art following a screening of *(nostalgia)* and other films, he expanded on this idea:

Time in the cinema is precisely as plastic, malleable, tactile as the physical substance of film itself. Plastic to a point that comes down to a bedrock when one puts up against the frame only twenty-four frames per second. When it comes down to that [time] *becomes rigid, though it can be compressed, attenuated. There is also something that is plastic, malleable, that is, if you will, tactile. The divisions go far past a twenty-fourth of a second and this, of course, is the vast organism, which passes through all of us and through which we pass, called consciousness. The consciousness of the passing of time, the density, the sense that something will happen, that nothing will happen.* [...] *Time is a name for something, which is a consciousness, which is a kind of irreducible condition of approaching, of being conscious of other things of plastic duration, not of expeditious chopping.*[4]

This film digs deeply into the affinity of time with consciousness. Given the amorphous and infinite nature of the subject to hand, some expeditious chopping is required to write about it. Here, we will home in on

how Frampton brought the form of his work, which includes words, photographs and, above all, fire in all of its stages to bear on the subject of nostalgia.

Only recently has Hollis Frampton's engagement with Walter Benjamin come to light.[5] What shocked me when I first saw *(nostalgia)* was that I felt I was also witnessing, for the first time, Benjamin's illusive dialectical image in action. As I began to read Frampton's essays, further affinities became apparent. Frampton never cites Benjamin, but they both use citation in a similar way. Their concerns with time, history and images, as well as their styles, perform a kind of cross-illumination, the results of which I hope to have recorded here.

Nostalgía and (nostalgía)

The title *(nostalgia)* refers to the first of seven films that comprise the series of films *Hapax Legomena*, released between 1971 and 1973.[6] In an interview with Peter Gidal, Frampton defined *Hapax Legomena* simply as 'Greek scholarly jargon; it means "said one time".' He mentions that there are 'several hundred, perhaps thousands of words that occur only once in Homer's work'. He goes on to give an example with English poetry: 'No poet, I think, since Shakespeare has dared to use the word *incarnadine*.[7] He really sapped that one dry. By default, a kind of vividness. For all intents and purposes *incarnadine* is a *hapax legomena* in English. Even though we know precisely what it means, we'll never use it again.'[8]

The meta-title *Hapax Legomena* suggests then that each film will be an instance in which something will be similarly 'sapped dry', its utility exhausted. While Frampton put himself in the company of Homer and Shakespeare in that exchange, the title of this first pseudo-autobiographical film in the series is humbled by parentheses and a lower-case initial letter. Reasons for this use of typography exceed autobiographical humility. The power of words to signify with authority, their power to name and thus dominate images, troubles much of Frampton's creative endeavour, and this film in particular.

Frampton explained the typography of the title by saying: 'As the parentheses in the main title of the first film, *(nostalgia)*, may have suggested to you, I have abandoned the use of main titles as irreconcilable photographic images.'[9] This is the only title included on any of the actual films in the series, and its parenthetical use here is evidence of an impending struggle between words and photographic images. He kept the word this one time, but belittled it, made it tentative, made an example out of it. The macho style with which he pitted Shakespeare as a victor over words — 'he really sapped that one dry'; 'we'll never use it again' — suggests not just a battle between words and images, but a war.

With regards to the meaning of nostalgia, Frampton's stated concern was with the more active Greek sense of the word, 'the wounds of returning', rather than mere *sehnsucht* or longing.[10] The word nostalgia comes from

two Greek roots, yet it's not a word that has travelled to us from Ancient Greece but from a Swiss doctor, Johannes Hofer, who invented it in 1688 to describe a medical condition. Our association of the word with Ancient Greece is already a kind of nostalgia, in a weak sense, in that we grant mythical power to an empty referent. The condition the physician Hofer was responding to afflicted various displaced people of seventeenth-century Europe: servants, students and especially soldiers. The preferred cure at the time was to get the patient home as fast as possible. Nostalgia, Hofer reports, symptomatically produced 'erroneous representations'.[11] Frampton's *(nostalgia)* indeed produces erroneous representations in that he shows you one thing and tells you something else altogether. Another symptom this film shares with the original disease is the hallucinogenic nature of watching a fire burn.

Nostalgia is customarily and by definition tied to place. 'The *nostos*,' writes contemporary philosopher Edward Casey, 'that is occasioning so much *algos* or pain ... is a return to the home place.'[12] He insists that occasions in which we are nostalgic about something that is placeless are rare. Much of the growing body of literature that seeks to redeem nostalgia from a passive loss in history to an active engagement with the past deals with a physical return. The literature is growing because nostalgia is growing. Back in 1936 Walter Benjamin described the predicament of the modern subject in the following way:

A generation that had gone to school in horse-drawn streetcars now stood under the open sky in a landscape where nothing remained unchanged but the clouds and, beneath those clouds, in a force field of destructive torrents and explosions, was the tiny, fragile human body.[13]

Modernity's shocks and shifts created a world of epistemic melancholia; it left us bewildered, lost and bewitched by technology, nostalgic for a when and a where in which time and space were easily felt and understood. Our present era looks back on that very loss with nostalgia, for it is a loss we never really experienced, yet it features prominently in our intellectual and social heritage. Now, physical borders continue to be re-drawn, political structures unhinged and remade, and just about everyone commutes to work. Often this commute is in the order of thousands of miles and returns home are rare. The much-maligned noisy smelly factory with its Taylorist mode of production romances us now, compared to the silent exploitation elsewhere that delivers the goods today. The 'erroneous representations' that Hofer reported correspond to the hallucinations now classified as a symptom of post-traumatic stress disorder afflicting today's soldiers returning from war. Whether we define nostalgia as a disease or a cure, the categories of 'displaced people' have multiplied so significantly since the seventeenth century that indeed it is fair to say that today displacement is the rule rather than the exception. Nostalgia has a long future.

Frampton's *(nostalgia)* also has this element of displace-
ment, for the photographs were all taken in the city
of New York, a city he was in the process of leaving.
Nostalgic narratives carry the sense of 'wounded return'
to a place and a time. Frampton was soon going to be
elsewhere; in the film he's returning from a place he
hasn't quite reached. Like Homer's *Odyssey*, like Joyce's
Ulysses for that matter, like Patrick Keiller's *London*
and *Robinson in Space* too, nostalgia is not just a painful
return home but a return from the future. Further,
it is a return to the past that makes the future possible.

Nostalgia lies somewhere between the private and the
public, between both speakable and unspeakable history.
The three senses in which it has been active according
to Edward Casey's 'The World of Nostalgia' are first as
a medical malady which was physical in cause and cure,
second as a Romantic position that was metaphysical
and generalised away from the literal and the personal,
and third as a kind of repressed, personal trouble.
'Since the Romantics,' Casey tells us, 'it has become
increasingly personal ... it has gone inward and
downward' and, with Freud, 'underground'.[14] Frampton's
photographs in *(nostalgia)* directly reference personal,
literal pasts. The space of time between the photographs'
making and the act of our looking, well, that's history.
Watching the photographs burn on the film screen,
however, belongs to the present. The film moves
outwards from a place that is literal and alone — the
darkroom where exposures are fussed over and developed
(figs.1 — 3) — through the lofts, galleries and streets of
New York City, and still further outward finally to the

public sphere of newsprint photography and anonymity. In so doing, Frampton also pulls the workings of nostalgia away from the tortures of personal malady to address the workings of history and the limits of representation.

The Work of Fire
The little blue flower is red![15]

In *The Psychoanalysis of Fire* Bachelard argues that the telos of Novalis's romantic quest, the infamous *'blaue Blume'*, is actually heat — heat that 'penetrates where the eye cannot go, where the hand cannot reach', heat that animates the interpenetration between people, between the imagination with the world, heat created when two things rub together.[16] We are more acquainted with that blue flower from the image conjured up in Benjamin's famous 'Artwork'[17] essay of a film studio so crowded with technology that the film image appears free of it: 'The equipment-free aspect of reality has here become the height of artifice, and the vision of immediate reality the Blue Flower in the land of technology.'[18] However ironically one cares to understand this, as the unattainable love that fuels the romantic quest or as a mere forget-me-not that now needs careful cultivation, Benjamin's simple point is that the film image emerges untainted out of the 'most intensive interpenetration of reality with equipment.'[19] Shot through with technological heat, the image is set free to move on its own. Although the image appears to exist in its own right, 'the equipment' — the technology of cameras, lights, electricity, emulsions and so on —

imparts its transformative power to the resulting
image; charges it, you might say.

Frampton's film takes this point literally for we
actually see the equipment take this film from stillness
to motion; we witness the hotplate's coils as they sear
through the image, forcing it to erupt into movement.
Apart from the invisible projector, heat alone animates
(nostalgia). As each photograph sits on the hotplate
its warmth slowly penetrates; the coil burns through
the image and sets it afire; smoke and flames twist
and turn until the photograph is a thin sheet of carbon
floating above the hotplate. When it is completely spent,
another photograph is offered up for sacrifice, and so
it goes until the film's end.

Another kind of heat propels the entire film, the heat
created when two things rub against each other, in
this case words against images. Each photograph is
narrated by a story about a photograph as an image
starts to burn. As you try to fit the story to the image,
the image becomes unintelligible. It then becomes
a little frustrating because things don't quite match
up, the image doesn't look like what the narrator is
describing. He describes a collage portrait of Carl Andre
(fig.4) that includes a metronome and a picture frame
but you are looking at an empty darkroom. Maybe, you
think, you missed something. You'll look closer next
time. Then you see a face and you hear the description
of a self-portrait. A careless observer might feel a bit
more sanguine if it weren't for the metronome appear-
ing in *this* frame. Dada associations notwithstanding,

fitting the image to the text is difficult. But the story so directly refers to the image, you are compelled to look for it. With the appearance of Hollis Frampton (fig.5) described as a shop window (fig.6), it is clear we are locked into a mug's game. The task of fitting the image to the text that describes its actual content, its date and place, isn't difficult at all, it's impossible. Nonetheless, we are associating words, be they the wrong ones, with the image now and then. The heat that moves this film along emanates not just from the friction between words and images, but the energy created when the past clashes with the present. This process elicits a far more active nostalgia than the lazy loop through a referent-less past with which the term is commonly associated. And it is these frictions, this heat, that distinguishes this film as a model way to address history from the ash heap it otherwise remains.

Although *(nostalgia)* is only about a small piece of one artist's manufactured history, the way Frampton uses film to address the problem of history is instructive. The abiding modern disease is the waning of experience, the loss of felt time and the ascent of representation, or mediated experience. Through his thaumaturgical activity, Frampton rescues the experience of temporality. In this, it can be thought of as another form of healing altogether.

From Zoroastrian purification to Aztec sacrifice, fire's vast ritual utility is hardly uniform. An example of ritual burning from the Cuna Indians of Central America has parallels to this film and to film

spectatorship in general. For when a Cuna Indian is very ill, that is when he or she is at risk of being attacked by evil spirits and killed, the Cunas take images from magazines and trade catalogues and burn them. In so doing, they release the spirit doubles of these photographs. These animated doubles then form a display of fascinating items. These things are so beguiling that they distract the evil spirits from their deadly task. So taken are they by this show of wares, the evil spirits forget all about harming the real sick person's body and go shopping instead.[20]

The burning of photographs in this film also performs a kind of healing by distraction. We wind through from real to imaginative associations, stopping to look and ponder at times, but being propelled by the external force of film's linearity — by the future — as we go along. Each burning releases the image from its fixed place in history to metamorphose and fit a new temporal register, as well as a different signifying function. The released image enables what Nietzsche called a 'plastic' relationship to the past. In his *Untimely Meditations*, Nietzsche was troubled by the 'uses and disadvantages of history for life', and he put the problem thus:

There is a degree of sleeplessness, of rumination, of the historical sense, which is harmful and ultimately fatal to the living thing, whether this living thing be a man or a people or a culture.[21]

Nietzsche thought one must be historical and unhistorical in equal measure. To be too bound to the past makes one unable to do anything; to be unhistorical is to fail to participate in the ebb and flow of thoughts and events. To serve life one has to develop a proper relationship to history, which depends upon how plastic a person, a people or a culture may be:

To determine this degree, and therewith the boundary at which the past has to be forgotten if it is not to become the gravedigger of the present, one would have to know exactly how great the plastic power of a man, a people, a culture is: I mean by plastic power the capacity to develop out of oneself in one's own way, to transform and incorporate into oneself what is past and foreign, to heal wounds, to replace what is lost, to recreate broken moulds.[22]

You can look at *(nostalgia)* as a kind of curing trip in which Frampton keeps the gravedigger at bay by developing and incorporating his own history, opens wounds so that they might heal, replaces that which is lost or in peril of being so, and burns them in order to activate the present. For Frampton true presence, unfettered by the past or thoughts of the future, was ecstasy.[23] Nietzsche called it happiness: 'the man of action avoids despair and disgust by turning his gaze backwards and pausing for breath in his march towards the goal. His goal, however is happiness ... he flees from resignation and needs history as a specific against it.'[24] The wounds of returning are wounds formed over time. History serves Frampton as a way of identifying them as such so that they can no longer do him harm.

Burning the photographs releases their spirit, dissipates their power to ensorcell, and replaces them with present distractions.

Nostalgia isn't a way of representing history, but of experiencing it, which is where the pain comes in. The photographs in *(nostalgia)* spark off remembrances of the past, and the new associations that we make watching them. The past maintains an abiding strain on representation, even, and perhaps especially, in those cases where history and context appear entirely absent, as in the static old photograph. Photographs absorb and contain time. Photographs on their own won't serve the demands of historical representation, and neither will a chronological account of events. Historical linearity, thinking of history as just one thing after another, was the crucial nemesis for historical materialists such as Siegfried Kracauer, Walter Benjamin and Theodor W. Adorno. For Kracauer, 'truth occurs — if at all — only in the realm of nature and only with the advent of a new temporality which is no longer the temporality of historical linearity'.[25] Benjamin describes his Arcades Project as 'comparable, in method, to the process of splitting the atom — [this work] liberates the enormous energies of history that are bound up in the "once upon a time" of classical historiography. The history that showed things "as they really were" was the strongest narcotic of the century.'[26] Adorno looked to what he once called 'Natural-History' to retransform concrete history into what he called 'dialectical nature', so that history no longer reclined as something natural.[27] Kracauer, Benjamin and Adorno

shared an urge to 'awaken' historical consciousness. Their attempts at this project resonate with Frampton's ideas about history in his writing, as well as the way the past features in *(nostalgia)*. Frampton's film does show the photographs in chronological order, except the first one, which is, incidentally, a Polaroid, therefore its original was destroyed making the film. The treatment of these photographs, however, transforms the narcotic into adrenaline. The chronological, show-and-tell form imitates a children's-book approach to history, but as you snuggle down for your bedtime story about the life of a photographer in downtown New York City, you awaken to a chase scene where time is twisted, relationships unhinged and chaos threatens around every corner.

'a man of his time'

(nostalgia) was released in 1971, on the heels of the highly acclaimed *Zorn's Lemma* (1970) with major screenings in New York at MoMA, in Minneapolis at the Walker Arts Centre and in London at the Filmmaker's Co-op. At the time of the film's making Frampton was teaching the history of film at the School of Visual Arts in New York City, and was a visiting lecturer at Cooper Union. Significantly, he was shifting his residence to New York's countryside, where he had purchased thirty acres of land and spent the summer in 1970. By 1974, he would live permanently in the countryside. A letter to Sally Dixon, dated 28 November 1970, refers to the completed film, so it's clear that the film was made at the point at which a shift from the city to the country was well on its way. She had queried him on the title,

to which he responded: 'That's right. Lower case, with parentheses. A bottomless pit of maudlin sentiment, fossilised cleverness and asynchrony.'[28]

The film was shot twice in its entirety, the first time using Frampton's own voice for the voice over, and the second time with Michael Snow's narration. Filmmaker Bill Brand, with whom Frampton worked on the processing of his films, estimates its production cost at between one- and two-thousand dollars, assuming no living expenses for Frampton himself and no fee for Michael Snow. It was made, like most avant-garde films at the time, with the filmmaker's own money and with the assistance of friends. Frampton describes this ostensibly biographical project in the third person: 'My subject, hoping abjectly to be taken for a man of his time, had practiced rigorous self-effacement for a decade or more. So I was forced into examining his leavings and middens like an archaeologist sifting for ostracising potshards. Since he had once been myself, I knew exactly where to look.'[29] Frampton's replacement of his own voice with Snow's sets the film further apart from autobiography. Yet, as a series of displacements and replacements, the film articulates an autobiographical sense of distance to people and places that had been central to that person he had once been, that person who was a photographer by trade. At the same time it is a document about an era; as Frampton put it, it is a 'systematic tour of the critical styles of the 60s, amongst other things.'[30] The film includes five portraits of his contemporaries — Carl Andre, Frank Stella (fig.8), James Rosenquist (fig.9),

Michael Snow (fig.13) and Larry Poons (fig.14) —
as well as a self-portrait.

There are jokes and references in the film that rely
on local knowledge. Frampton's friends were painters,
sculptors and dancers who were each trying to make
their forms do new things. Chief among them were
the sculptor Carl Andre, the painter Frank Stella,
and the composer Frederic Rzewski, all of whom were
classmates at Phillips Academy, Andover, Massachusetts,
in the years 1951—54, and with whom he resumed
contact upon moving to New York City in 1958. Of that
period he says:

*In my film there is a re-mastering of a certain number
of lumps I took during those years as a still photographer
in New York. You noticed that there are no triumphs
described in the film; it was by no means a time that
I look back to in the current pathetic sense of 'nostalgia'
at all. It was quite dreadful. I didn't find it a picnic to be
a photographer through the sixties, not because photography
was disregarded, although of course that was true, but
because my predicament was that of a committed illusionist
in an environment that was officially dedicated to the
eradication of illusion and, of course, utterly dominated
by painting and sculpture. At that time I didn't understand
how luxurious it was to find myself alienated in that way.*[31]

Bear in mind that at the time you had Jackson Pollock
punching people out at the Cedar Bar, Andy Warhol's
Sleep screening in 1963 with Jonas Mekas tying people
to chairs to force them to watch, Warhol walking out

because he was bored, as well as a brewing eruption of 'radical aspirations' for cinema in the works of Kenneth Anger, Stan Brakhage, Michael Snow and Joyce Wieland, to name only a few. Perhaps even more influential for Frampton was the fledgling performance scene whose participants are now renowned: Twyla Tharp, Meredith Monk and, most important to Frampton, Yvonne Rainer. He recounts a dance performance of Rainer's, *Three Satie Spoons*, solo dances to *Three Pieces in the Shape of a Pear* in which 'she started making *noises*: little mewing sounds, squeaks, bleats'.[32] Frampton 'was electrified, because it was totally disjunctive within the situation. There she was in a black leotard, doing something that *looked like a dance*. What was memorable was a violent disruption of, a transgression against, the culturally expected, which had been introduced into the very heart of the thing. What was important was not that she made the specific noises that she did, but that that single gesture broke open the whole decorum of dance. But again, what did she have to lose?'[33] The kinship between Rainer and Frampton goes beyond his admiration for her transgression in this particular instance, both soon went on to become filmmakers. Moreover, their work shares an attitude: constricted subjectivity, extreme care with language, deadpan wit, in all a cleverness for which their work is at times disliked, admired or forgiven.

Frampton has often been referred to as a 'structural' filmmaker.[34] This is a term that P. Adams Sitney created to describe a body of films in which he observed common attributes and concerns wherein

'the film insists on its shape, and what content it has is minimal and subsidiary to its outline'.[35] Though few 'structural' films had all of the attributes Sitney defined ('fixed camera, flicker effect, loop-printing and re-photographing from the screen'), as A.L. Rees points out, the label's hold was tenacious.[36] Frampton eschewed the label, writing in a letter to Peter Gidal:

I said to Sitney, at dinner in July: I have found your Structuralists, P. Adams, and they are in England. Complete to the diacritical mark, influence of Warhol, the whole number. You see, Peter, most of us to whom that tag has been stuck, are a little (or more than a little) exercised about it…. Personally, I believe Structuralism is a term that should have been left in France, to confound all Gaul for another generation.[37]

It is fair to say, however, that Frampton, along with Michael Snow, Ken Jacobs and George Landow (now Owen Land), for example, made films that interrogated cinematic form to the degree that their structure, to some interpreters, became their subject matter. In A.L. Rees's account of the movement, he contextualises structural film as a movement away from 'pure vision' towards thinking about the cognitive effects of cinema, away from populism (underground and pop art) onto the high ground of the avant-garde, and away from abstract expressionism towards minimalism.[38] They are films in which you think and watch at the same time, films in which you think about your watching and watch what you are thinking whilst the sights and sounds communicate directly with your nervous system.

They are an open invitation to the viewer to come alive in the cinema. Left to their own devices, these films make philosophers of us all.

'Don't forget,' James Benning warned 'how funny it is.'[39] Another wrong turn easily taken makes geeks of too earnest viewers and readers. Frampton's mathematical formulae, his over-reliance on Greek, along with the puzzle-like structures he puts before us, tempt and taunt his viewers and readers.[40] Doubly so, because there is always a good chance that he is having you on.[41] (nostalgia) repeatedly repays credulity with manifest dissimulation, and as it does so, you become wedged into a double bind. You know he's up to something, and you'd better figure it out before it's too late. For the possibility that this film might never really be seen again haunts one's initial experience of viewing. This is worth remembering as we turn now to a discussion of the film's form.

Form and Formlessness

As a documentary of Frampton's movement from photography to film, (nostalgia) articulates, in a form that is minimal, tightly ordered, overly structured and at the same time always subject to the arbitrariness controlled by nature alone, the redemptive potential of cinema. Each sequence goes through three stages. In the first, which lasts about thirty seconds, we see a perfectly legible photograph and we hear nothing. In the second, the photograph burns to the sound of a narration for a minute or so. The third part is silent and lasts almost as long as the narration lasted. In it

we watch the thin sheet of carbon gently move about in its last throes. We watch infinitesimal gestures, stuttering movement, we check for signs of life. Even though it is shot and projected at normal speed, this third portion of each segment has all the properties of slow motion — slow motion, moreover, in close-up. We watch these forms with micro-physiognomic eyes. They are movement in close-up, which for theorist and filmmaker Jean Epstein was 'the soul of the cinema'. These weighty moments of silence and carbon are the fruition of the complete 'penetration' of the photograph by the equipment, of which Benjamin wrote: 'Evidently, a different nature opens itself to the naked eye — if only because an unconsciously penetrated space is substituted for a space consciously explored by man.'[42] The nature of this different nature, one delivered to us by a machine, was to Jean Epstein for one, sacred:

I would even go so far as to say that the cinema is polytheuristic and theogonic. Those lives it creates, by summoning objects out of the shadows of indifference into the light of dramatic concern, have little in common with human life. These lives are like the life in charms and amulets, the ominous, tabooed objects of certain primitive religions. If we wish to understand how an animal, a plant or a stone can inspire respect, fear and horror, those three most sacred sentiments, I think we must watch them on the screen, living their mysterious silent lives, alien to the human sensibility.[43]

As Philippe Dubois suggests, 'Burning a photograph is only an extension of the photographic process: the

photograph is a sensitive surface (like the soul) burned
by the light that strikes it, and gnawed from within
by the very things that allow it to exist: light and
time.'[44] With the photograph absolutely exposed, at
this stage, all that is latent in the photograph is of
utmost dramatic concern. What is latent, of course,
is lost time, never more manifest than here in these
cinders, as time's residue itself becomes animate.

Frampton had something a bit different to say about
these silent moments. He refers to a radio show from
his childhood called *Suspense*, which aired an episode
entitled 'Chicken Heart' about a scientist who cultured
the tissue of the heart of a chick embryo:

*As it cultured, this little muscle did not form the shape of
a heart but was simply a mass that grew ever larger until
finally it escaped from its Petri dish and began to acquire
whatever nourishment it needed in the environment until
the whole planet was covered with sodden, beating chicken-
heart tissue. Very early in the program, as an incessant kind
of ostinato background for all the other speeches and all the
other sounds, one began to hear very softly the sound of a
heartbeat that grew in volume throughout the thirty minutes,
until finally the scientist and his girlfriend, the lab assistant
— presumably the last people alive — were up in a light air-
plane, with no place to land, and over the enormous beating
of the heart, one heard the sound of the engines drumming
and missing, sputtering and then dying, and that was
the last sound except for the beating of the heart for what
probably amounted to fifteen seconds, a very long time
in radio. There was absolute dead air, the supreme* verboten

of radio. That silence entirely engulfed the intellectual
space of the imagined listener, so that in a gesture that
Cage presumably would like, it was filled with speculations.
I admit that in duplicating a gesture of that kind in film,
there's an element of shabby carnival rhetoric.[45]

The sound in *(nostalgia)* performs this pattern from
the murmured rhythm of a beating heart to hissing,
sputtering and then dying into speculative silence. If
you add the film's image to the sound, it re-enacts the
entire crescendo Frampton describes here, over and over
again. For as you watch the photograph burn, no matter
how dull the voice is, it becomes just noise as you try
to make sense of the relationship of the image to the
sound. The image from the radio describes an expanding
sodden mass of tissue, growing from a simple culture
to consume the entire planet. Like the radio model,
Frampton's film advances from a laboratory to consume
the outside world. Most striking, however, is that on
both a visual and sonic level form dissipates and form-
lessness ascends. Each sequence evolves from legibility
though cognitive chaos to illegibility, from form
through disorder to the *informe*. Rescuing formlessness
from form's disciplining hold, Georges Bataille wrote:

Formless … is a term that serves to bring things down in
the world, generally requiring that each thing have its form.
What it designates has no rights in any sense and gets itself
squashed everywhere, like a spider or an earthworm. In fact,
for academic men to be happy, the universe would have to
take shape. All of philosophy has no other goal: it is a matter
of giving a frock coat to what is, a mathematical frock coat.[46]

With each appearance of the silent floating carbon the film carries us towards the randomness and the amorphousness of the *informe*. This is not a mere negation of form but a movement towards pure materiality. From image to image, formlessness and pre-history lurk under and behind, and the world that carries on as if its frock coat were only natural begins to look presumptuous, if not strange. For after this reverent moment of speculative silence, there is a brief pause of blackness, sobering us once again to the rules of the cognitive game.

This transformation from form to *informe* is the work of fire. Both a compelling object of contemplation and an elemental subject that can change and destroy, the significance of fire is limitless. Bachelard's observation that 'fire is both cookery and the apocalypse' is particularly relevant for a film that burns photographs on a hotplate.[47] Just as relevant is Walter Benjamin's assertion that when delving into the secrets of modernity — its technology, for instance — the archaic is never that far off.

Though all of these associations might serve *(nostalgia)*, Frampton's connection of fire to time is of central importance to the film's form, for it is only in these moments that language enters the film. The following anecdote exemplifies Frampton's concern with the capacity of language to capture time, and here he recounts his only 'verbal report from the domain of ecstatic time' in his essay 'Incisions in History/ Segments of Eternity'.[48] Frampton is captivated by

the story of a racing-car driver whose car, travelling at 620 miles per hour, went out of control and 'sheared off a number of handy telephone poles, topped a small rise, turned upside down, flew through the air and landed in a salt pond' in the period of 'some 8.7 seconds'.[49] The driver, Breedlove, was unhurt. Breedlove made a tape to record the thoughts he had during those seconds. The tape lasts an hour and thirty-five minutes. Still, Frampton says, Breedlove was condensing, curtailing, making an even longer story short, at a ratio of some '655 to one'.[50]

Frampton compares Breedlove's temporal expansion to Proust, Joyce and Beckett. But Breedlove's most amazing remark, for Frampton, is that which he uttered when he emerged from the wreckage: 'For my next act, I'll set myself on fire.'[51] The hour-and-thirty-five-minute monologue is, in some important way, that act of burning. Burning condenses the entirety of the experience into carbon, and its release in smoky words is never quite adequate to the task. The equation of setting something on fire (in this case Breedlove's own body) with the verbal enormity of what a second contains — temporality — is central to an understanding of *(nostalgia)*. The choice between burning, on the one hand, and baroque but always inadequate language, on the other, stands as Frampton's model for the representation of past time. This choice becomes both mandatory and impossible in the course of viewing Frampton's film, *(nostalgia)*.

The Darkroom

The film's first and last sequences conjure a darkroom. In the film's final voice-over the narrator describes wandering about with his camera in 1966 when 'the receding perspective of an alley caught my eye ... a dark tunnel with the cross-street beyond, brightly lit'. Because of an obstruction the composition was spoiled, reports the narrator, 'but I felt a perverse impulse to make the exposure anyway'. Then, after blowing up a 'tiny detail' of this photograph, that was itself a reflection of a reflection, over and over again, the narrator was faced with an image that, he says, 'fills me with such fear, such utter dread and loathing, that I think I shall never dare to make another photograph again'. He pauses, and turning the film over to the spectator, he says, 'Look at it. Do you see what I see?' The final image is a complete exposure of black that fills the entire screen. In one sense, the film is the story of a photographic career from beginning to end.

Eleven of the images that make up the film were culled from photographs of artists, artworks, urban scenes and photographic studies that Frampton made in the seven-year period between 1959 and 1966. The first image we see, however, has no date and is never discussed in the film, for it sets the disjointed narration in motion. It is a Polaroid of a darkroom, and the narration that accompanies it has points of contact that almost make it seem to fit the picture. The image is, after all, slowly burning up as the narration begins, so you have little time to check the story for accuracy. It is quite plausible that an image of a darkroom would

be the first he made, as the narrator claims, 'with the direct intention of making art'. The timer to the right of the frame stays visible long enough before burning up to mentally rhyme with the word metronome (for they both tick off time), which, the narrator reports, 'he eventually discarded after tolerating its syncopation for quite a while'. The mention of Carl Andre, nothing more now than a puff of smoke (as the photograph is almost gone), begins a series of bittersweet references to people who have since become more distant. The narrator concludes: 'I see less of him nowadays than I should like; but then there are other people of whom I see more than I care to. I despised this photograph for several years. But I could never bring myself to destroy a negative so incriminating.'

The fit with the narration is also plausible in that the photograph of a darkroom would now be 'despised', as the narrator claims, by someone who has since rejected photography; moreover, the darkroom as a site of concealment and revelation features as an off-screen reference in the film. Even though we later learn that there isn't a fit between the words you hear and the image you see, with this first image we are still busied in this mug's game.

As this is a story of a photographer turned filmmaker, the burning of the darkroom really needs no narration. But destroying a darkroom does have an obvious extra-textual reference. Hollis Frampton denied, when questioned in a 1973 evening session at the Museum of Modern Art, any influence from Antonioni's

Blow Up (1966). The question was surely motivated by the correspondence between the pivotal scene of *Blow Up* and the story recounted in the final voice-over of *(nostalgia)*, and also by their shared assessments of photography, including the trashing of the darkroom in another scene in Antonioni's film. Frampton responded, '"Blow up" is a problematic phrase. Someone accused me of a reference to Antonioni. I had seen it, it was sort of — I was entertained. I can't recall having *Blow Up* on my mind. The images don't partake of the same metaphoric bread. The mind is working as hard as ever it can to make a pattern.'[52] To Frampton's denial, P. Adams Sitney responded in the 1985 evening session at MoMA in honour of Hollis Frampton after his death, that there was no question of the film's relevance to *(nostalgia)*. For Sitney, *Blow Up*, released just about the time that Frampton was giving up photography, 'sexified' the photographer and marked the beginning of an era in which everyone became an urban, roving, photographic voyeur, similar in character to the one constructed in both films.[53] So there was Frampton; he'd been that photographer before it was sexy, and now everyone was doing it. Time to burn up the darkroom.

The Metronome
The second photograph extends a Dadaist's invitation. In its solemn composition, it does indeed look like a vain attempt at artiness. But as we look at the face of Carl Andre, his hand holding the tip of the metronome's pendulum and an ornamented frame surrounding his head, we hear that this is a self-portrait. This is an

in-joke, for only those in the art world would know either face well enough to spot the substitution. There are many such jokes in the film, some of which only Frampton would actually get. But this image is funny enough on its own, first because of its forced composition, and second because the composition — with the prominence of Andre's eyes and the metronome — along with the narration's allusion to 'tolerating its syncopation' recalls a famous Man Ray piece once named *Object to Be Destroyed*. Man Ray's instructions for making the object went as follows: 'Cut out the eye from a photograph of one who has been loved but is seen no more. Attach the eye to the pendulum of a metronome and regulate the weight to suit the tempo desired. Keep going to the limit of endurance. With a hammer well-aimed, try to destroy the whole at a single blow.'[54] When set against the synchronous text (the one that is actually describing the next photograph), the reference is compounded. The piece by Man Ray was itself both re-made and re-named, which is just what the narrator is talking about. Man Ray's *Indestructible Object* of 1923 sports a metronome with a photograph of an eye. It was originally titled *Object to Be Destroyed* but an onlooker took Man Ray at his word, so Man Ray renamed its replacement *Indestructible Object*. Keeping this association, of the replacement of an object to be destroyed with an indestructible object, this photograph easily fits the story as it burns, for we quickly see only Andre's face as the photo combusts to become a pathetic lump of carbon as the narration winds to a close.

The voice-over ends:

I take some comfort in realising that my entire physical body has been replaced more than once since it made this portrait of its face. However, I understand that my central nervous system is an exception.

The film has a lot of this sort of thing.

But the nervous system, as even its name indicates, is poor solace as a constant in your body. The more specialised the organ, the less regenerative its cells. The nervous system is the most special of all, its tissue is irreplaceable. Like the structure of the film, the nervous system is both a system and a nerve centre, prey to all manner of reactions. Continually shifting between moments of intangibility and destruction, silence and the frenzy of language, the film's simple, albeit confounding, structure is unstable, nerve-wracking, nervous. The nervous system, the body's centre of control and chaos, is a favourite theme, or better, a target for avant-garde film. Ken Jacobs, a filmmaker who was Frampton's contemporary, has made an ongoing series of films since 1996, for example, that tirelessly aims at reaching its very core through live dual-projections which destabilise our sensory control, which he calls *The Nervous System.*

Mount Fujiyama
The third image, the narration announces, is of a shop window. The image is unmistakably a posed portrait

of a man — a man I now believe to be Hollis Frampton. Very much in the same fashion that a classical Hollywood film would reveal its star, we hear quite a bit about this fellow in the first few scenes of the movie — we even hear his voice off-screen say 'it's all right' while Snow tests the microphone at the beginning of the film, and several film-*noir*ish suggestions are made about changing identity — when there it is, the close-up of a face. Frampton's face, if you knew what he looked like or believed a word he said, if indeed you could recall the previous account clearly enough. Spectators on their guard, however, would only believe that it's not a shop window and wonder if it's his nose or his ear that's curling up as the narrator says, 'I had thought my subject changeless, and my own sensibility pliable. But I was wrong about that.' This sequence not only unveils Frampton, but the conceit of the film as well.

He's lying to you, to your face, with his face. This is also where the narration takes a doubtful turn, never to be abandoned. Doubtful about photography's ability to record, and doubtful about the stability of what is actually there. We could be tempted not to bother with either anymore if it weren't for the possibility that we might, with a bit more work, remember enough about the last story to fit it to the following image.

Frampton is counting on what he once called the 'gravitational mass' that he associates with narrative. He began his essay 'Pentagram for Conjuring the Narrative' with this remark:

A spectre is haunting the cinema: the spectre of narrative.
If that apparition is an Angel, we must embrace it; and if
it is a Devil, then we must cast it out. But we cannot know
what it is until we have met it face to face.[55]

One of the essay's five sections discusses narrative's
sheer force. 'Whatever is inevitable,' he writes,
'however arbitrary its origins, acquires through custom
something like gravitational mass, and gathers about
itself a resonant nimbus of metaphoric energy.'[56]
As 'Mount Fujiyama is visible from absolutely every
place in Japan' and 'looms from every direction
at once', so too the 'spectre of narrative' haunts the
cinema.[57] And just as readily as Fuji reigns as the
supreme metaphor in Japan, narrative can take shape
from the most haphazard of collages.

While we watch his face burn up, the narrator is
describing a collage of sorts, the window of a dusty
cabinetmaker's shop that he had photographed over a
two-year period. The window, we are told, was different
every time: 'Once, a horse was reflected in the glass,
although I don't recall seeing that horse. Once, I found
myself reflected, with my camera and tripod.' These
are the sorts of apparitions and chance associations that
hang about as you watch the photographs metamorphose
throughout the film. Gravitational mass pulls in two
ways at once in the case of this film. We make scattered
associations between the mismatched text and the image,
while at the same time we strain to retain the story
and fix it with the next photograph. That we nonethe-
less go along with it, despite such extreme pressures,

attests to the weight of narrative. It could hardly be
otherwise, for the 'centre of the cosmos is occupied
by the Polyhedron of the Story-Teller'. He concludes
'Pentagram for Conjuring the Narrative' with
a thought that describes much of the reverie of
watching *(nostalgia)*:

Nor do all facets [of the Polyhedron] *bear images. Some are
dust, some cracked; some are filled with senseless images
of insects, or else with a vague, churning scarlet, shot with
sparks. Some are as transparent as gin. Some are bright
as mirrors and reflect our own faces … and then our eyes …
and behind our eyes, distantly, our polyhedral thoughts,
glinting, wheeling like galaxies.*[58]

Art
The film moves on from photography to address
other artistic forms. As we look at the picture of
the cabinetmaker's window, which looks a bit like
a cubist painting, the narrator recounts how he tried
imitating action painting, much to the displeasure
of a neighbouring painter: 'A young painter, who lived
on the floor above me, wanted to be an Old Master.
He talked a great deal about gums and varnishes;
he was on his way to impastos of record thickness …
I spent a month photographing junk and rubble,
in imitation of action painting.' As the narrator utters
the words 'gums and varnishes', flames shoot out of
the image as if to comment on the rival's pretensions
to mastery. To seduce the rival's girlfriend, the narrator
produced a carving in clay that he then cast in plaster.
As the photograph of the cast is displayed and burned

in the following sequence, he ponders the distinction between craft and art. The narrator recounts how, on looking at a photograph of Frank Stella, he is reminded 'unaccountably, of a photograph of another artist squirting water out of his mouth, which is undoubtedly art. Blowing smoke rings seems more of a craft. Ordinarily, only opera singers make art with their mouths.'

The picture we are looking at now is of the plaster cast that the narrator reports he had made in order to impress a woman. In the previous sequence, the narrator had described 'making a realistic work of art' called *A Cast of Thousands* (fig.7) which is 'realistic' to a fault. The current narration, about a picture of Frank Stella, mouths and making art, is a direct reference to Bruce Nauman's famous *Self Portrait as a Fountain*, which is part of Nauman's *Eleven Color Photographs* (1966–67/70) series. A different photograph in Nauman's series, another viewer claims, would directly reference the image at which we are in fact looking. Like Frampton's plaster cast of the number '1000', carved twice then entitled *A Cast of Thousands*, Nauman's *Waxing Hot* is a visual pun. It shows a can of wax and a hand polishing the word 'HOT', rendered in three-dimensional, spit-polished form.[59] How planned, unconscious or arbitrary such connections between the text and image are meant to be we'll never know, nor does it matter. The point is in our conjuring.

Like a little Prometheus, Frampton is also breaking a taboo with his fires. 'Bomb the museum!', he once said.

'I will part gladly with the work of five years, into the bargain.'[60] The burnt images represent the work of seven, not five years from Frampton's career; however, his sacrifice of his own work pales by comparison to the destruction he metes out. Like the Dadaists and Surrealists before him, Frampton disapproved of the elevation of art. 'Carl Andre, old friend,' he said, 'I here accuse you of believing that art, first and foremost, should be elevating. I suggest instead that we elevate ourselves.'[61] His treatment of these fellows in the film, not only Andre, but Stella, the nameless painter upstairs in his building and even James Rosenquist, amounts to a Dadaist assault. The film, in effect, burns their paints and varnishes, steals their girlfriends and takes ridiculous pictures of them. Frampton makes sport of, or otherwise defaces, all the plastic arts, yet he leaves written forms unscathed. He aligned himself with Duchamp and, more specifically, his attention to language: 'The rumour anyway that my mother's name was Rrose Sélavy is substantially correct, and I think she has something to teach us all about the intimacy of the ties between language and perception.'[62] Most odious to Frampton about abstract expressionism, specifically, was the elevation of art over language: 'The terms of indictment [by the painters of the 1950s and 60s] were clear: language was suspect as the defender of illusion, and both must be purged together in the interest of a rematerialisation of a tradition besieged by the superior illusions of photography. Only the poetics of the title escaped inquisition, for a time.'[63]

Words and Images

That the monologue in *(nostalgia)* always coincides precisely with the image's destruction acts as a kind of retaliation for the primacy of the image that was brought to a head with abstract expressionism: words burning images. This linguistic arson goes a long way to redress the primacy of the image and tries to reinstate language, not only language as expression and language that might reduce mythic artistic authority, but also language as a tactile force, albeit a monotonous force, into artistic practice. Frampton thought carefully about the sound of the voice, rejecting his own because of the way it sounded, and also to add more distance from self-revelation:

My voice is essentially a kind of radio announcer's voice (I think I learned to talk as much from the radio as I did from people), which means that it tends to over-enunciate histrionically. At one point I did record my own voice reading that script, and it was just awful.... The reason I finally settled on Mike — except for the possibility of generating a couple of internal jokes — was that Mike has that flat Ontario Scottish delivery. Every now and then, when the Scottish element in that speech suddenly pops forward, I almost expect him to break into a recitation of an Edinburgh menu. His is not, let us say, the standard Minnesota American English that the radio announcer speaks. My tendency is to imitate Richard Burton in a bathtub.[64]

The grain of Snow's voice is a 'flat' one; his measured articulation, easy cadence and tempered volume resonate from his body to the listener's ear. However

repetitive its rhythm, however monotonous its melody, the narration carries its bodily origin with it, and so transmits its presence directly to the spectator. The return of language to art practice does not in itself bring with it the clear calm of reason. By putting in words that compete with the image, Frampton is pushing the limits of filmic expression, not simply to do so but because the subject requires it. In his writing, Frampton frequently articulates the tension between customary dirty language and apparently pure images. He quotes Niels Bohr's remark on a camping trip in the Alps: 'Our language is like our dishwashing: we have only dirty water and dirty dishrags, and yet we manage to get everything clean.'[65] His discussions about photography, by contrast, continually refer to its freedom from language (for better and for worse). Frampton voices his 'irrational suspicion' of language in reference to Diane Arbus's photographs: 'Freaks, nudists, transvestites, masked imbeciles, twins and triplets inhabit an encyclopaedia of ambiguities buried *so far beneath language* that we feel a familiar vague terror at the very suggestion of being asked to speak of them ... an irrational suspicion that, should we ever find and utter a name for what these images mean to us, we would so profane them that they might vanish like Eurydice, or fall to dust.'[66]

But both words and images share a common problem, the elusive nature of time. Neither photography nor writing can represent the present. Although one could argue that the tension between language and image, and between present and past are the abiding concerns

of all writing, the particular way this tension operates as the motor force in both Frampton's work and Benjamin's writing on history illuminates the inadequacy of thinking about history as a continuum, as well as the sheer futility of simply writing it out sequentially.

Among the many similarities between the problems that Benjamin and Frampton encounter regarding language in general, they both make the same sort of remark about their subject's — that is, history's — specific demands. Frampton inserts a comment into his essay 'Incisions in History' that simply registers the difficulty of the task: 'At times [history] seems impervious to language.' Frampton complains that while he sits and writes about history he cannot, at the same time, convey the image of the window out of which he looks, nor the desires he compresses. 'Instead,' he says, 'I am enmeshed in these words. But I can't find the words to tell you what it is like to be writing them.'[67]

Like Frampton, Benjamin often refers to the process of writing and making history at the same time. In 'Theoretics of Knowledge, Theory of Progress', Benjamin tries to incorporate the moment of writing into the text: 'Say something about the method of composition itself; how everything that comes to mind has at all costs to be incorporated into the work one is doing at the time. Be it that its intensity is thereby disclosed, or that from the first, the ideas bear the work within them as telos. So it is with the present [text], which

should characterise and maintain the intervals of reflection, the distances between the most intensively extroverted, essential parts of the work.'[68] Benjamin's continual insistence that the form of the work be the nerve-centre of meaning makes it crucial to write the process of history-writing into the text. Both Frampton and Benjamin pause frequently to alert the reader to the author's task. Often this takes the form of a preoccupation with windows, the desire prompted by the language-free world of images that is only to be complicated by the knowledge that those images are always, in an urgent way, laden with language. Both texts are driven by the tension between the primacy of the inchoate image on the one hand, and the power of language to fix meaning on the other. The window, for example, that Frampton wants to write into his scholar's study 'and escape through it into the sunshine of an abrupt summary' suggests the abiding seduction of the image.[69] But the written window, which displaces that other window through which Frampton looked to find images, is inadequate and injurious to the complexities of meanings he thinks and sees. Benjamin looks out of a real window that he keeps free from the fetters of language: 'the glassed-in spot facing my seat at the Staatsbibliothek. Charmed circle inviolate; virgin terrain for the souls of figures I conjured.'[70]

In the midst of their seduction by lucid language, they both voice the necessity to refrain from violating the image. In (nostalgia) the profaned image, the burnt photograph spent by language that quivers in front of us, registers this fall precipitated by language. That this is

the same language that Frampton now chooses to deploy but that also served as a weapon against the authority of the image accounts for the most devastating sense of 'torsion' in the film as well as the periodic allusions to fire, smoke and violence in his text.[71] This torsion of language on images and images on words is completely caught up in that other torsion I spoke of earlier, the torsion of the past turning on the present while the present turns on the past. This double torsion, of image to language and past to present, holds potential energy. Benjamin, with his concept of the dialectical image, and Frampton, with this film, both harness that energy.

Homesickness

The penultimate image in the film is a found photograph from a newspaper. Its story, however, comes to us as we see a posed photograph of the painter Larry Poons aflame. The voice-over describes the newspaper photograph (figs.15 — 17) as if it was a picture of a person without a living referent:

A stubby, middle-aged man wearing a baseball cap looks back in matter-of-fact dismay or disgruntlement at the camera. It has caught him in the midst of a display of spheres, each about the size of a grapefruit and of some non-descript colour. He holds four of them in his cupped hands. The rest seem half-submerged in water, or else lying in something like mud. A vague mottled mass behind the crouching man suggests foliage.

This photograph has no context, no reference at all, the narrator claims. It is a photograph without

a history. Along similar lines Siegfried Kracauer, in his study of photography, describes how old photographs become ahistoric in the hands of strangers. The ahistorical photograph, Kracauer argues, creates a spatial continuum that carries no meaning and, effacing history, records only the remnants of nature. This facility to record empirical nature is not 'nature in a positive sense, ie. the immediacy of physis, but rather nature as the negation of history. When photography records history it simultaneously annihilates every historical context.'[72] Nature, the vague mottled mass, emerges from the anonymous photograph much as Kracauer described it:

As long as the object is still present outside the photograph, the latter will be read as a sign of a reality. Only when even the memory of this reality has disappeared does the mimetic aspect of photography come to the fore; it becomes an archive of the residues of nature, which are devoid of meaning, unintelligible, and, indeed, have never been perceived.[73]

In *(nostalgia)* the description of mud, foliage and the residue of nature in an otherwise referentless photograph (we are still only about to see) proffer not plenitude but melancholia on a grand, natural scale. The voice-over says:

I am as puzzled and mildly distressed by the sight of this photograph as its protagonist seems to be with the spheres. They seem absolutely alien, and not very forbidding, after all.

The narrator suggests that a context, an anecdote like the others, would resolve the alienation that the photograph provokes and he offers a plausible scenario — a fruit-grower assessing the damage to his grapefruit orchard by a hurricane. Yet, this arbitrary reasoning to make sense of the photograph doesn't turn out to be completely satisfactory. Freed from historical reality, the narration shifts the photograph through time and changes its significance once again: 'Were photography of greater antiquity, then this image might date from the time of, let us say, Pascal, and I suppose he would have understood it quite differently.' This next interpretation takes us back — back to 'natural' referents, back to the ravages of entropy, and back to fire.

Pascal, whom you could call melancholia's philosopher, might have seen the image as a model of a man perplexed by infinity. Pascal's illustration shows that finitude is impossible to reach through pursuing nature's vast heavens or its most tiny progeny:

But if imagination halts there [in the stars]*, let imagination pass beyond; it will fail to form a conception long before Nature fails to supply material. The whole visible world is but an imperceptible speck in the ample bosom of Nature. No notion comes near it. Though we may extend our thought beyond imaginable space, yet compared with reality we bring to birth mere atoms. Nature is an infinite sphere whereof the centre is everywhere, the circumference nowhere. In short, imagination is brought to silence at the thought, and that is the most perceptible sign of the all-power of God.*[74]

This puts man, both a small speck within infinity and a body that contains still another infinite universe, in a state of eternal homesickness to which one can only be resigned, for Pascal, through God:

We sail over a vast expanse, ever uncertain, ever adrift, carried to and fro. To whatever point we think to fix and fasten ourselves it shifts and leaves us; and if we pursue it, it escapes our grasp, slips away, fleeing in eternal flight. Nothing stays for us. That is our condition, natural, yet most contrary to our inclination; we have a burning desire to find a sure resting place.[75]

The image that begins Pascal's declaration of the faith that accepts man's eternal homesickness is fire. The ratio of words to time is poorer here than in Frampton's account of the racing-car driver, Breedlove: 'On Monday night, 23rd of November 1654, Pascal had a mystical experience, a conversion. It lasted about two hours, and he wrote twenty-seven lines.' The memorial begins: 'FIRE / God of Abraham, God of Isaac, God of Jacob, not of the philosophers and scholars. / Certitude. Certitude. Feeling. Joy. Peace.'[76] Nonetheless the declaration qualifies as another example of a 'verbal report from the domain of ecstatic time' that Frampton mentioned in his 'Incisions in History' essay that herald from 'Saints, the berserk and the possessed'.[77] We proceed from the photograph of a man lost in history to an image of man lost in time and space, in a state of eternal homesickness, a state of existential nostalgia, whose acceptance, maybe even redemption, as the invocation of Pascal suggests, begins with fire.

The End

The next image shows the newspaper photograph anticipated by the previous description, while the narrator winds through his final anecdote. The voice-over reports that we are seeing the enlargement of a twice-reflected speck, the 'tiny detail' that Frampton saw when developing a photograph he had blown up over and over again. This is the image that, the narrator says, 'fills me with such fear and such dread that I think I shall never dare to make another photograph again'. This is an enlargement of one of the millions of dots Kracauer must ignore to see the diva, the waves and the hotel in the beginning of his essay on photography. Here, Kracauer imagines using a magnifying glass and sees 'the millions of little dots that constitute the diva' on the cover of an illustrated magazine.[78] In Kracauer's terms, the black speck would represent history's residue, which so defies representation within the limits of photography. In the story of the film the narrator approaches the taking and reproduction of the final image cautiously and obsessively. This stubborn speck is the unseen, uncontrollable time and space that, when exposed, magnified even, persists as black residue. When the narrator says, 'Look at it, do you see what I see?', the next frame, accompanied by silence, shows a completely black screen (fig.18).

There is some debate about the film's final image and, not surprisingly, there are even two versions about the taking of this exposure from Frampton himself. Here is his account at a question-and-answer session held after screening *(nostalgia)* at MoMA in 1973,

although the question he is answering didn't make
it onto the tape:

*There was not. There was an incident that did involve the
alley, the truck door, the two mirrors and I decided not
to make the exposure. That represented a juncture at which
something was demanded of me as an artist and I never
quite figured out what it was. There was something. There
was a shot there but I couldn't make the shot at the same
time. I remember very vividly and did for years between
the time it happened and writing about it. It became
emblematic, the best metaphor I could achieve.*[79]

He never made the exposure. According to this, it
was a shot he couldn't make. What you see, depending
on which print you see (how much black leader there
is at the end of the film) and how you interpret what
you see, is either a black screen or Frampton's logo.
You can interpret it as the introduction to the rest
of *Hapax Legomena*, the end of a loop that directs
you back to the beginning of the film, the final touch
of an autobiography with the HF logo; or you can
understand the black screen to be that enlargement
which yielded no visual information. Queried about
this by Scott MacDonald, Frampton was quick to
eschew the autobiographical take:

*Let me jump in right there. What is seen in the fragment
of the photograph, reflected and re-reflected in the rear-view
mirror of a truck, is certainly not my logo. As you may have
noticed, that was the last film in which I used either the
logo or a title at the beginning.... The darkness in* (nostalgia)

is there to separate the logo from the last image so that your present confusion could be avoided. I may even get around to dropping the logo on that film. It might work better to have it simply trail off into darkness.[80]

To my mind, the black image or leader is a completely exposed piece of film, for that is what you see. I take this to mean no image, in the sense that what is there can't be photographed. Frampton defined film as 'whatever will pass through a projector'. Moreover, 'the least that will do is nothing at all. Such a film has been made. It is the only unique film in existence.'[81] That film may be the lecture demonstration, in which Frampton ran an empty projector to show that film inevitably subtracts to make images, where he said: 'Our white triangle [the film screen with a projector projecting only light] is not "nothing at all". In fact it is, in the end, all we have. That is one of the limits of the art of film.'[82] The black leader can, in this context, justifiably signify the opposite of 'all we have'. If fire is the signature of redemption in a world haunted by infinity, by epistemic melancholia, and if the temporality of film portends our modern rescue, this black speck, the literal representation of what persistently resists capture, is surely the imprint of modernity's hell.

The anonymous text of the newspaper photograph, whose explication ranges from a news item to a philosophy, is but an extreme example from *(nostalgia)* that will neither fix meaning nor deny it. In this film, however, this is more significant than generic avant-garde

insouciance. The context of the photographs, and thus history itself, is both shifting within and essential to the film's form. This shifting is part and parcel of the stories Frampton tells, the lumps he takes as he returns home. Think how trite, indeed how wrong, a film on nostalgia would be that, for example, told those tales while the 'correct' image burned. That would suggest, simply, that the experience of the narrator was once there and is now gone. This is not unlike what happens in the final image of *Citizen Kane* where the mystery word peels and burns, and history and meaning go up through the chimney in diegetic smoke, leaving viewers with the sense that they grasp something that is otherwise irretrievable. That mnemonic bonfire, its referents neatly fixed into the film, produces pathos. Only a heavy organ pedal is left to settle the score, leaving merely the note's resonance to register the far trickier issue of what remains.

Frampton's method, by contrast, casts doubt on what was there, unfixes the image from its story, and places the story, which is, after all, a narrative form in the present, in constant peril of being subsumed by the burning image and becoming the past. In this, the film not only enacts nostalgia and melancholia but shock as well. The spectator's ability to contemplate is mercilessly and repeatedly placed in a state of constant peril, producing such anxiety that a 'breach in the shield against stimuli' renders him or her vulnerable to the films tactile force.[83] Another viewer describes the film's effect on him:

The end result [of the entire film] *is the ruin of represen-*
tation and a fascinating experiment in time. The psychic
effect produced by the continuous viewing of the photo-
graph's auto-consumption is intense, as if we felt physically
that this carbonisation of memory-images were actually
taking place. We are left with the shrivelled fragments of
a life that in the end is little more than ashes. Something
irreparable has happened before our very eyes.[84]

So the viewer sits, perched precariously between the
now of the fire's erratic burning with its narrative
score and the continual reminder of silence and
burnt carbon.

Watching these ashes adds yet another temporal layer
to the film's structure. There are already a few. The
photographs come from specific times in the recent
past. The stories as we hear them are spoken while
the fires burn and are part of the present, simultaneous
with our viewing, but they wander into these past
moments. The voice-over anecdotes also refer to other
pasts to which we don't have access, exposures he didn't
print, negatives that are lost and exposures he couldn't
take, which amount to a pro-filmic reality in the past
that remains unrecovered. Such references also hint at
the existence of an infinite cinema to which Frampton
was constantly referring, like the cinema discovered,
for example, at Oaxaca and Tehuantepec in a cache
of proto-American artefacts: '[they] consisted of some
75,000 identical copper solar emblems, in the form of
reels, each of which was wound with about 300 metres
of a transparent substance, uniformly 32 millimetres

wide, that proved upon microscopic examination to be made of dried and flattened dog intestine'.[85] These, it turns out, were hand-painted pictograms that had, moreover, been 'optically projected upon the walls', condensing sunlight with mirrors for illumination and using 'lenses of water contained in glass bottles' for focus.[86] This 'discovery' is one of many references in Frampton's writing that insist on the archaic presence of infinite cinema. The photographs Frampton puts into *(nostalgia)* are culled from a limitless array of images: 'A still photograph is simply an isolated form taken out of the infinite cinema.' This archive awaits resplendent:

A polymorphous camera has always turned, and will turn forever, its lens focused upon all the appearances of the world. Before the invention of still photography, the frames of the infinite cinema were blank, black leader; then a few images began to appear upon the endless ribbon of film. Since the birth of the photographic cinema, all the frames are filled with images.[87]

Underneath the many temporal layers of the film resides a formless, archaic past that technologies, from time to time, might partially reveal. Across the surface of these layers of time is the visceral present, the fire that engages us in the now. The 'irreparable' destruction these fires mete out also make us keenly aware of the present, 'before our very eyes'.

Although fire performs many a mighty task for the structure of *(nostalgia)*, looked at in another way it

doesn't 'work' at all, but instead opens the door for playful, metonymic visions. Sergei Eisenstein had called visions we see while gazing at a fire 'a cradle of metonymies'.[88] Unlike the linear involvement of the dream or the distanced perspective of a critic, watching fire, for Gaston Bachelard, 'leads to a very special kind of attention which has nothing in common with the attention involved in watching or observing ... one must engage in reverie on a specific object ... this reverie works in a star pattern, it returns to its centre to shoot out new beams'.[89] The animation that fire produced, thought Eisenstein, provided an opening through which what he called 'sensuous thought' could emerge:

Persistent suggestion through fire, the appearance of fire, the play of fire, images of fire are capable in certain cases of provoking 'unconscious' and 'impulsive' conditions — that is, of bringing 'sensuous thought' to the foreground, and forcing 'consciousness' into the background.[90]

The metamorphosing flames in *(nostalgia)* do let our minds wander sufficiently to make free associations between the bits of burning image and the words we hear. These moments, when flashes of meaning break through to the present in an all but arbitrary fashion, are what Benjamin would call 'the image of the now'. While the film parodies chronology, makes rubbish of history, burns it to ashes, it offers the experience of temporality in return. If the text had matched its image, the image's legibility would obscure the complex layers of time at work in a true experience of history-laden time. 'Every present day,' wrote Benjamin, 'is

determined by the images that are synchronic with it: each "now" is the now of a particular recognisability. In it, truth is charged to the bursting point with time.'[91] Frampton takes these images that are 'synchronic with time', these photographs that are in truth 'charged to bursting with time', and by burning them releases what has been locked up within them. Benjamin adds, 'This point of explosion, and nothing else, is the death of the *intentio*, which thus coincides with the birth of authentic historical time, the time of truth.'[92] If only in the humble form of a brief life story, Frampton creates such a death and birth.

The Dialectical Image

Benjamin and Frampton, both concerned with pulling images out of 'historic time', articulate that action as awakening. Benjamin writes: 'Just as Proust begins his life story with waking, so must every representation of history begin with waking; in fact, it should deal with nothing else.'[93] In turn, thinking of Joyce, Frampton writes: 'Even James Joyce, the most ardent of newsreel devotees, said that history was a nightmare from which he was trying to awake.'[94] Their shared aversion to continuous, historical time sets them looking for a way to shock moments, images, ideas, monads out of that time and hold them in an instant. For Frampton, 'lasting amusement' and 'sustenance' are achieved in the 'awakening to an alternate and authentic temporality of ecstasy'. He goes on: 'It is obvious that historic time, though quite well suited to the needs of matter, is a terrain too sparse to afford the mind any lasting amusement or sustenance. So we

must clear out, stand aside and enter, if we can,
the alternate and authentic temporality of ecstasy.
I assume that everybody knows what that is.'[95]
In the spirit of melancholia, temporality's foil,
it's tempting to reply, 'I wish I did'. For Benjamin,
no stranger to melancholia, waking was no less
revolutionary and equally lofty. He begins section 'N'
of *The Arcades Project* with a line from one of Marx's
letters: 'The reformation of consciousness lies *solely*
in our waking the world ... from its dream about
itself.'[96] In *(nostalgia)*, Frampton wrests the image
out of its place in a historical continuum, out of the
'infinite cinema', as he put it when repudiating all
others in favour of the photographic arts, to 'arrest
consciousness and suspend its objects of contemplation,
outside the ravages of entropy'.[97]

Waking and burning, shocking and blasting — clearly
history's demands on representation are violent and
urgent ones for Frampton and Benjamin. And all this
for a representation that is only transitory: '...the
dialectical image is like lightning. The past must
be held like an image flashing in the moment of
recognition. A rescue thus — and only thus — achieved,
can only be effected on that which, in the next moment,
is already irretrievably lost.'[98] This passage from
Benjamin suggests, in one highly condensed burst,
the important affinity for fiery history that Frampton
shares. But, unlike 'the prophet's gaze, which catches
fire from the summits of the past', the fire here comes
from old photos. The film is both a systematic rationing
out of these images, to be understood in the context

of a text now hardly completely recoverable but
nonetheless possible to assimilate through memory
and curiosity in a rough manner to the next image,
and a nervous play of mnemonics. The ungovernable
way in which a burn coincides with a text enacts
the erasure of one meaning and the re-enchantment
by another.

Benjamin puts a portion of a letter from Adorno, busy
trying to rearticulate the concept of a dialectical image
in no-nonsense prose, into *The Arcades Project*. Adorno's
recapitulation separates the concept into stages in a
way that would never have tempted Benjamin, but these
stages are useful not only to explicate the concept but
to see how, with their temporary clarity, Frampton's
use of photographs in *(nostalgia)* can approach the status
of dialectical images, and thus illuminate a new sort
of life, or afterlife, of objects.

Benjamin's quotation from Adorno begins with an
account of the object's descent from use to exchange value
and reification: 'As things lose their use value, they are
hollowed out in their alienation and, as ciphers, draw
meanings in.'[99] Things become interchangeable and have
no inherent meaning. Similarly, Frampton thought that
all photographs were the same, they were just so many
'gradations of the grey scale'. Moving quickly from their
short-lived, hollowed-out object status, Adorno then
characterises their fetishisation, or their second nature:
'Subjectivity takes control of them, by loading them
with intentions of wish and anxiety.'[100] Frampton uses
one photograph to stand in for another by inserting

a photograph whose meaning has already been spent in front of us while we listen to the story of another photograph. Quite literally, 'things stand in for other things'. Frampton then takes control of them with his text and loads them with 'wish and anxiety'. Our wish to see the matching image and our anxiety that they will never match up are major concerns during the burning and its narration. More literally, the narration is filled with wish and anxiety. For example, when the narrator expresses regret about using inappropriate lettering in a poster for an exhibition by Michael Snow, the text reads: 'I wish I could apologise to him for that.' The narrator is, after all, Snow himself. For further regret, Snow turned to Frampton during the recording of the text, looked up from the script and said, 'Well, why don't you?', to which Frampton replied, 'I wish I could'.[101] Such laments about the past occur frequently in the film. Wish and anxiety recur in the text as well as through the disturbing smoky form that the image takes on during its narration.

Adorno further characterises fetishisation: 'Because the dead things stand in as images of subjective intentions, these latter present themselves as original and eternal.'[102] Frampton, like Benjamin and Adorno, short-circuits the image's fetishisation. Though Frampton loads his text with 'wish and anxiety', he does not fetishise the image, for he does not attach this new meaning — the text — to the image you see. Instead, he burns that image.

It is at this point, the point of burning, the point of potential but denied fetishisation, or re-fixing the image that Adorno's definition of the dialectical images can begin. Benjamin's idea was to harness the power of the fetish: 'Dialectical images are constellations of alienated things and thorough-going meaning, pausing a moment in the balance of death and meaning.'[103] His definition articulates an apt description of Frampton's burning, then quivering, images. The alienated things (the photographs) are momentarily caught in the balance between death (burnt carbon) and meaning (its story, which awaits in the next sequence along with its replacement). In this liminal stage, the burning image is balanced in a 'constellation of new meaning'.

This new and transitory meaning is governed by the all but arbitrary fit of the mismatched text to the photo, and also the very direct materiality of flames and smoke. The meaning produced here relies on the temporality of this complex conjunction of words, images, past, present and future, or, in other words, on the properties of cinema itself. The film is hyper-filmic in these instances, relying on the tension between movement and time, as well as language's narration. Remember, these are the sequences when the still image comes alive. And it is just here, when photography turns into film, that Frampton removes the very possibility of the distance contemplation requires, with his fiery assault and disjunction of narration to image. He so confounds contemplation in order to make the desire for cognition, not normally

associated with tactility, itself a palpable one. There is no moment when a photograph can be considered with its story, yet by using these stories he repeatedly invokes the pleasure of such relaxing contemplation only to deny it over and over again until the film's final frame. For the fatigued viewer, temporality is everything, with each and every frame.

The quick and barely containable act of burning is crucial to temporality — that is, the experience of a piece of language-laden, image-filled time. Frampton's concern with temporality in this complex sense, like Kracauer's faith in a 'new temporality', is similar to the dialectical tension Benjamin wants to create between the past and the present with the dialectical image:

It's not that what is past casts its light on what is present or what is present its light on what is past; rather, image is that wherein what has been comes together in a flash with the now to form a constellation. In other words, image is dialectics at a standstill. For while the relation of the present to the past is a purely temporal, continuous one, the relation of what-has-been to the now is dialectical: is not progression but image, suddenly emergent.— Only dialectical images are genuine (that is, not archaic); and the place where one encounters them is language. Awakening.[104]

Benjamin describes the dialectical image in one simultaneous burst, but Adorno's distinct phases illustrate how the power of the fetish could be harnessed to form dialectical images. For Benjamin, this was the most

powerful way to renegotiate meaning in his industrial age. He thus amended Adorno's passage when he placed it in *The Arcades Project* with the remark: 'With regard to these reflections, it should be kept in mind that, in the nineteenth century, the number of "hollowed out" things increases at a rate and on a scale that was previously unknown, for technological progress is continually withdrawing newly introduced objects from circulation.'[105]

Frampton's concern, however, is not to re-function commodity fetishism. It is both more general *and* more specific. Frampton's images are fetishes from the past. Like the commodity fetish, their meanings now bear a different yet powerful relationship to their original and long-gone context while appearing to have none at all. Whereas the dialectical torsion of the film enacts the same kind of temporality that Benjamin theorises, Frampton, in his written work, pits ecstatic, authentic temporality against the ravages of 'entropy', not against mythic authority, as artistic representation's abiding concern 'as if to repudiate, in the spasmodic single gesture of revulsion only half-sensed, the wavering concerns of painting, purifying and reclaiming for itself those perfected illusions, spatial and tactile, which alone could arrest consciousness, and suspend its objects of contemplation, outside the ravages of entropy'.[106] Entropy is less a historical or political diffusion of meaning than the alienation-charged mystification that concerned Benjamin. But for filmmaking and aesthetics, the way Frampton works language and image away from entropy and towards

temporality, and from photography towards film, *(nostalgia)* could hardly be more so charged. Through his new medium, Frampton re-functions the 'utensils' of his artistic practice.

Amid the throes of technology's rapid acceleration, the task of re-functioning images and exposing disintegration was, for Benjamin, an urgent one, 'at once a consequence and condition of technology.... The perceptual worlds [*Merkwelten*] break up more rapidly; what they contain of the mythic comes more quickly and more brutally to the fore; and a wholly different perceptual world must be speedily set up to oppose it. This is how the accelerated tempo of technology appears in light of the primal history of the present.'[107]

Frampton hits on the utopian possibilities of cinema while discarding photography in favour of film. In our present electronic age, which Frampton marks with the advent of radar, it is inconceivable that one could rework discarded utensils apace with technology.[108] (Although it is possible to see Frampton's voracious mastery of ever-newer technologies' specific powers in that way.) Instead, Frampton hones away at the crucial properties of cinema — movement, language and reproducibility — and compounds its two modes of perception: contemplative distance and tactile immediacy. In this journey from photography to film, Frampton galvanises their immanent antagonistic dynamics along with competing temporal registers in the service of activating nostalgia. Not by accident

but because of the requirements of his historical task, he created what Benjamin called dialectical images in the process. By so producing that which most evades consciousness — both ecstatic temporality and its horrid inverse — Frampton restores cinema's magical power to curse and to cure.

Nostalgía: 1971—2005

Uppers are no longer stylish. Methedrine is almost as rare, on the 1971 market, as pure acid or DMT. 'Consciousness Expansion' went out with LBJ ... and it is worth noting, historically, that downers came in with Nixon. [109]
— Hunter S. Thompson

Nostalgia itself is now looked to for its curative powers. Anthropologists and historians have recently sought out its utopian potential. Aware of nostalgia's ubiquity, they prefer to redeem rather than condemn its emergence. When, where and how it gained its present status is a question whose answer remains anecdotal, at best. These author's claims, however, resonate not only with Benjamin's redemption of history with the dialectical image, but also, at moments, with the form that Frampton's *(nostalgia)* takes on.

From Lazlow and Johnston's melancholic song, 'My old flame', through Bachelard's metonymic 'reverie' in fire, the connection between burning and nostalgia continues to register its effect on consciousness, if not the body itself. Svetlana Boym begins her book *The Future of Nostalgia* with the story of a return from

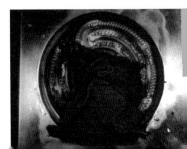

West to the former East Germany after the opening
of their border. A man, she recounts, kneeling at
the edge of a once-familiar river bent down to wash
his face in its waters and was burnt by its toxins.[110]
This clash of romance for a non-existent past with
the realities of time's wear and tear is a hallmark
of ill-considered returns home. This anecdote is set
forth as an example of nostalgia's dangers by a writer
who herself is suffering from a ten-year displacement.
In itself, the notion that the past can burn you isn't
a revelation, and for her it stands as an example of
'restorative' nostalgia, a nostalgia, which for Boym
in its desire to restore the past triumphant and
unchanged, has fascist potential.

Boym's example of what a cinematic image of
'redemptive' nostalgia would look like, by contrast,
apparently pulled from the air, not only reiterates
the forces at play in the multi-layered structure
of Benjamin's dialectical image, but also describes
Frampton's film with astonishing precision:

*A cinematic image of nostalgia is a double exposure,
or a superimposition of two images — of home and abroad,
past and present, dream and everyday life. The moment
we try to force it into a single image, it breaks the frame
or burns the surface.*[111]

Frampton's *(nostalgia)* manages the superimposition
of past (the image from the past) and present (the
voice-over in the present); of dream (the metonymic
associations watching the flames) and everyday life

(the quotidian nature of the anecdotes, wandering through the city streets, visiting friends); and when forced together, they burn the surface. But what about home and abroad? The sense of place in this film is somewhat overwhelmed by its temporal concerns. The home which the narrator revisits is presumably his milieu in New York City, and abroad is just 'apart', for he only refers to where he is in the present with the remark, 'James Rosenquist and I live far apart now, and we seldom meet. But I cannot recall one moment spent in his company that I didn't completely enjoy.' All we can gather is that he is no longer there. Home place becomes, in the course of the film, no place.

Invocations of utopia and the future distinguish definitions of nostalgia from those that see it as merely being consumed by a non-existent past. Boym distinguishes between 'restorative' and 'redemptive' nostalgia with the former taking on the negative, nationalistic traits interested in origins and the fixing of history, and the latter privileged as a social phenomenon interested in details and associations rather than symbols. As in Frampton's nostalgia, she is after the metonym not the metaphor. Frampton too, you will recall, distinguished between 'the wounds of returning' and mere 'sehnsucht or longing'.[112] Kathleen Stewart argues that alongside the retro-fitting of history much derided by Fredric Jameson and others, another creative and future-oriented nostalgia emerges that is not commercial in form. But first, when and how did we come to need nostalgia? What accounts for its emergence?

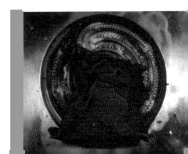

The 'when' seems to come in the seventies, 1971 if you take Hunter S. Thompson at his word. His *Fear and Loathing in Las Vegas* was written in 1971, the year of *(nostalgia)*'s release, and looks back five or six years to peak moments of 1960s elation. Remembering watching the Ali-Frazier fight, however, goes like this:

A very painful experience in every way, a proper end to the 60s: Tim Leary a prisoner of Eldridge Cleaver in Algeria, Bob Dylan clipping coupons in Greenwich Village, both Kennedys murdered by mutants, Owsley folding napkins on Terminal Island, and finally Cassius/Ali belted incredibly off his pedestal by a human hamburger, a man on the verge of death. Joe Frazier, like Nixon, had finally prevailed for reasons that people like me refused to understand — at least not out loud. [...] But that [the 1960s] was some other era, burned out and long gone from the brutish realities of this foul year of Our Lord, 1971.[113]

Moreover, he complains, kids these days go straight to 'the needle' (ie. heroin) from Seconol, 'they don't even bother to *try* speed'.[114]

More proof that 1971 was the year comes from Frampton. In an interview conducted somewhere between 1976 and 1978, Frampton said: 'It strikes me as historically unfortunate that the word "nostalgia" itself was resuscitated such a short time after I made that film.'[115] Svetlana Boym states boldly: 'The twentieth century began with a futuristic utopia and ended with nostalgia. Optimistic belief in the future was discarded like an outmoded spaceship sometime in the 1960s.'[116]

Patrick Keiller writes that the 1970s were 'often charac-
terised as a decade of failure, economic stagnation and
the slide into neo-liberalism, in which the emancipatory
promises of the 1960s signally failed to materialise'.[117]
However, he contests that 'the 1970s were the period
in which many aspects of our present economic reality
were first put in place. We live now in a future, not
as it was imagined in the 1960s, but as it was actually
constructed in the 1970s.' Again, evidence for the onset
of nostalgia points to 'the early 1970s':

*The early 1970s are also the period most often associated
with the 'shift in the structure of feeling' that separates
modernity from post-modernity, when the coherent
imagination of alternative better futures has largely
disappeared, so that while we might see ourselves living
in a version of a previous period's future, we have no such
imagined future of our own.*[118]

Somewhere around 1971, uppers went out and downers
came in; the futurism, which from the historical avant-
garde to the mid-century's space age aspired to the
radically new, left the planet; flight from the city
to the suburbs and the countryside began; and Sun Ra,
finding the world bereft of utopian possibilities decided
that space was the place. Nostalgia replaced utopian
ventures and slowly took over the redemptive project.
No place became home place. In this process, a careful
set of definitions emerged, skinning nostalgia of its
fat, separating off the supermarket runs of pop tunes
from that which might actually have resonance with
historical intimations.

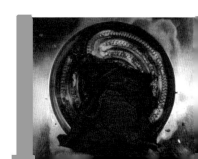

The first to do this was Frampton himself, carefully distancing his film from the looming low-rent longing that has since overtaken us. In a polemic defence of nostalgia as a cultural form, Kathleen Stewart argues that nostalgia 'sets in motion a dialectic of closeness and distanciation; its goal is not the creation of a code based on empty distinctions but the redemption of expressive images and speech'.[119] While mindful of the banality at work in commodified history, she sees it finally as a creative, potentially utopian practice. She was writing from the United States in 1985, moved by her fieldwork experiences in Appalachia to rescue the concept from the grips of Disney's historical theme parks and all manner of culture's reification, so prevalent at the time.

She reports first on a rising phenomenon, now familiar to us, of people moving from the city to the country to create 'historic' villages, perfecting them by restoring and moving buildings like churches, inns and school-houses from nearby sites, in her example, a town at the eastern tip of Long Island. In the process, they have pushed out, or alienated those whose home it was by rights, people who 'either ignore the effort to create the "the look" and leave their snow ploughs and old trucks in the yard, or deliberately inscribe their disruptive, fragmenting signs on top of the look or in its midst'.[120] A man who was told he should paint his body shop, for example, finally gave in and painted graffiti all over it in day-glow colours. By scarring their empty nostalgia, the long-time resident locals enacted their nostalgia for the actual place 'before' it was remodelled and, in

Stewart's assessment, created a ruin with allegorical potential. 'Allegories,' wrote Walter Benjamin, 'are, in the realm of thoughts, what ruins are in the realm of things.'[121] Ruins stand as the evidence of time's wear, as remnants from a distant past, and as the site, most importantly, of loss. The presence of ruins corrodes the stability of the present, they stand by, ready to reveal a detail, a flash of light, or a thought from which one might find a purchase on the present, before it becomes the past. Furthermore, 'for radical natural-historical thought,' wrote Adorno, '*everything existing* transforms itself into ruins and fragment ... where signification is discovered, in which nature and history interweave.'[122] To see things splintered, decayed rather than in packaged, static form is the task of the historical materialist.

Creating ruins is the work of survival. The city dweller's nostalgia is for a place that never was, and furthermore never was theirs, whereas the local's nostalgia is for their rightful home with all of its imperfections. This healthier nostalgia activates the visual landscape by spatial, cultural and temporal disruption. Mimicking urban defacement, the rural painter stirs up the town's present with a new temporal (and cultural) register by constructing a ruin in their midst. You can imagine the anarchic delight that someone who has not invested in either past might feel when driving through. The delights of defacement are not lost on the viewers of Frampton's film either. (To watch photographs of famous artists burn and to listen to a text that is mismatching, and thus irreverent

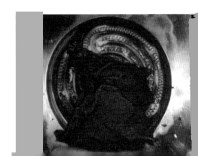

to the person, produces a similar superficial delight.)
The sort of nostalgia that interests Stewart (and
Frampton) involves a temporal disturbance; it isn't
a simple, contained relapse into times now past.

Stewart describes a far more dour scene in Raleigh
County, West Virginia, where the 'local' economy of
coal has collapsed and the unemployment in the area is
total and final, where the people 'live in the ruins and
fragments of the old coal camps'. The place is literally
emptying out 'in mass migrations set off by a wave of
unemployment that sweeps through the region like an
act of God'.[123] It is in this discussion that she introduces
a utopian aspect of nostalgia. Living amongst the ruins,
in an environment that is emptied out, the people fill
the void mostly with talk. Although the local landscape
has been ravaged by history, 'people roam from ruin
to ruin reading out the absences they embody, reading
out how "thangs have got down anymore", dwelling
in the mournful desire they represent'.[124] The remnants
take on a subjective presence that performs the work
of delivering the past to the present. She was told,
for example:

*Those wild roses ramble around the chimney in 'the old
Graham place' field because the house is gone, and the
Graham family is gone and the ideal 'used to' of the family
farms is also gone. The vacancy ... of a lot 'remembers'
the fire that burned Johnny Millsap to death.... An exposed
electrical wire in the hills above Amigo Mines #2 remembers
that in 1980 Buddy Hall, a nine-year-old boy, was
electrocuted on it.*[125]

Things act not just as catalysts for remembering, but as active mediums; they haunt the present and nostalgia becomes the 'responsibility to remember what happens, especially those things that "try" to erase someone'.[126] Instead of emptiness, the people fill the present with talk; talk about what was and about what if; talk that extends their place to the America outside and to the future with tales of those who have migrated to the cities for work. In Stewart's analysis of this particular situation, nostalgia fills the emptiness of the present with the past and the future. Nostalgia is, in Stewart's sense, to visit ruins.

While changes in local landscape and migration are hardly new to the twentieth and twenty-first centuries, signs of a shift from a future-driven society to a nostalgic one now permeate literature, film and academic enquiry. The memoir is a favoured current literary genre; films set in the future are invariably dystopic, while historical films increase and aim at grittier, grainier, more genuine resurrections of the past and 'memory studies' abounds in the academy. The prospect emerges that nostalgia alone constitutes our relationship to the past, at least for now. Nostalgia, in any of its definitions, circumvents pernicious positivism as regards the authority of history and addresses, instead, the way the past features in our consciousness.

Equally pertinent, however, is that there are better and worse nostalgias. One can be ahistorical to a fault. You can forget, for example, that your 'old flame' never

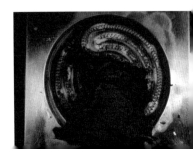

kept a job, and wasn't even a very nice person, only to pine for that thing he never was. You can ignore the violent changes in the former Soviet Union, and burn your face in a river. Frampton's *(nostalgia)* suggests that a dialectical relationship between past and present is possible, but also that its revelations are fragile and fleeting. As in Benjamin's dialectical image, these are moments of revelation that flash; they don't burn. The problem of a proper, yet horribly compelling link to the past won't go away, hence the urge to enlist nostalgia's power but disinfect it for theoretical purity. The question becomes not what do we want from the past, but what do we want from nostalgia?

In making *(nostalgia)*, Frampton described himself as an archaeologist, examining 'leavings and middens … sifting for ostracising potshards'.[127] The present encloses us in such leavings, in the form of ruins, images and various pneumonic traces in which a world of effaced relationships lies dormant. These relationships are, for each of us, by turns historical, political, autobiographical, archaic and aesthetic. Access to this momentous mix of myth, nature, history and sensation lies not in a utopian past, but in those traces that surround us. Thus ascends the urge to enliven that which lies dormant, to stir the 'sentient springs' that portend our awakening.[128] Nostalgia answers such an urge.

1
Bruce Jenkins and Susan Krane, *Hollis Frampton: Recollections and Recreations*, Cambridge: MIT Press, 1984, p.56.

2
Blaise Pascal, *Pensées*, trans. H.F. Stewart, London: Routledge, Kegan Paul, 1950, p.35.

3
Hollis Frampton, 'Erotic Predicaments for Camera', *October*, no.32, Spring 1985, p.56. This text was written in April 1982.

4
'An Evening with Hollis Frampton', 8 March 1973. Sound Recordings of Museum-Related Events, 70.22. The Museum of Modern Art Archives, New York.

5
Hollis Frampton, 'The Invention Without a Future', *October*, no.109, Summer 2004, pp.65—75.

6
Bruce Jenkins's unpublished dissertation is the only text that deals with the entire series of films, and in which he convincingly argues that they constitute Frampton's meta-history of film. The rest of the titles in the series are: *Poetic Justice*; *Critical Mass*; *Travelling Matte*; *Ordinary Matter*; *Remote Control*; and *Special Effects* (1971—73). See Bruce Jenkins, *The Films of Hollis Frampton: A Critical Study*, Evanston: Northwestern University, 1983.

7
Here it is in context, as it is found in *Macbeth*, Act I, Scene 2, for the example turns out to be characteristically apposite:
Whence is that knocking?
How is't with me, when every noise appals me?
What hands are here? ha! they pluck out mine eyes.
Will all great Neptune's ocean wash this blood
Clean from my hand? No, this my hand will rather
The multitudinous seas incarnadine,
Making the green one red.

8
Peter Gidal, 'Interview with Hollis Frampton', *October*, no.32, Spring 1985, p.103.

9
Hollis Frampton, 'Hollis Frampton: Three Talks at Millennium', *Millennium Film Journal*, Fall/Winter 1986—87, p.275.

10
Scott MacDonald, *A Critical Cinema*, Berkeley: University of California Press, 1998, p.60.

11
Johannes Hofer, as cited in Svetlana Boym, *The Future of Nostalgia*, New York: Basic Books, 2001, p.3.

12
Edward Casey, 'The World of Nostalgia', *Man and his World*, no.20, 1987, pp.361–84.

13
Walter Benjamin, 'The Storyteller', *Selected Writings*, Vol.3, trans. Edmund Jephcott *et al.*, Cambridge and London: Belknap Press, 2002, p.144.

14
E. Casey, *op. cit.*, pp.369–72.

15
Gaston Bachelard, *The Psychoanalysis of Fire*, trans. Alan C.M. Ross, Boston: Beacon Press, 1964, p.41.

16
The 'blue flower' is now infamous because of its translation in the first, widely read English version of Walther Benjamin's 'Artwork' essay (see below) as not a 'blue flower' but an orchid, which led Miriam Hansen not only to point out this mistranslation, but to investigate its possible ironic connotation in Miriam Hansen, 'Benjamin, Cinema and Experience: The Blue Flower in the Land of Technology', *New German Critique*, no.40, Winter 1987, p.204.

17
Walter Benjamin 'The Work of Art in the Age of Its Technological Reproducibility', second version, *Selected Writings*, Vol.3, *op cit.*, pp.101–40.

18
Ibid., p.115.

19
Ibid., p.116.

20
Erland Nordenskiøld and Henry Wassen (eds.), *An Historical and Ethnological Survey of the Cuna Indians*, Gothenburg: Goteborgs Museum Etnografiska Avelningen, 1938, pp.353, 366 and 398.

21
Friedrich Nietzsche, *Untimely Meditations*, trans. R.J. Hollingdale, Cambridge University Press, 1997, p.62.

22
Ibid.

23
Hollis Frampton, *Circles of Confusion*, Rochester: Visual Studies Workshop Press, 1983, pp.96–99. In these pages Frampton refers to the 'authentic temporality of ecstasy', 'consciousness at work in ecstatic time', and gives a few examples.

24
F. Nietzsche, *op. cit.*, p.68.

25
Heide Schlüpmann, 'Kracauer's Phenomenology of Film', trans. Tom Levin, *New German Critique*, no.40, Winter 1987, p.113.

26
Walter Benjamin, *The Arcades Project*, trans. Howard Eiland and Kevin McLaughlin, Cambridge and London: Belknap Press, 1999, p.463.

27
Theodor W. Adorno, 'The Idea of Natural-History', trans. Bob Hullot-Kentor, *Telos*, no.60, Summer 1984, p.117.

28
Courtesy Anthology Film Archives.

29
H. Frampton, 'Hollis Frampton: Three Talks…', *op. cit.*, p.274.

30
'An Evening with Hollis Frampton', 8 March 1973. SR, 70.22. MoMA Archives NY.

31
S. MacDonald, *op. cit.*, pp.60–61.

32
Ibid., pp.29–30.

33
Ibid.

34
Bruce Jenkins's dissertation on Hollis Frampton provides a comprehensive account of the ways in which thinking through Frampton's films as structuralist impoverishes their full meaning and effect.

35
As cited in A.L. Rees, *A History of Experimental Film and Video*, London: BFI, 1999, p.74.

36
As cited and paraphrased in A.L. Rees, *ibid.*

37
The letter is dated 25 August 1972. See Peter Gidal (ed.), *Structural Film Anthology*, London: BFI, 1978, p.77.

38
A.L. Rees, *op. cit.*, pp.72–75.

39
Telephone conversation with the artist, July 2005.

40
Apart from the film title *Zorn's Lemma*, see, for instance, Frampton's mathematical equations to characterise various authors' narrative constructions that begins with Gertrude Stein: $x = x$, in H. Frampton, 'Pentagram for Conjuring the Narrative', *Circles of Confusion, op. cit.*, p.66.

41
See Barry Goldensohn, 'Memoir of Hollis Frampton' pp.7–16 and Christopher Phillips, 'Word and Image', pp.75–76 for examples of his purposeful dissembling, both in *October*, no.32, Spring 1985.

42
W. Benjamin, *Selected Writings, op. cit.*, p.117.

43
Jean Epstein, 'On Certain Characteristics of *Photogenie*', in '*Bonjour cinéma* and other writings', trans. Tom Milne, *Afterimage*, no.10, 1981, p.22, delivered as a lecture in the fall of 1923.

44
Philippe Dubois, 'Photography *Mise-en-Film*', trans. Lynne Kirby, in Patrice Petro (ed.), *Fugitive Images*, Bloomington: Indiana University Press, 1995, p.169.

45
S. MacDonald, *op. cit.*, pp.61–62.

46
Georges Bataille, *Visions of Excess*, trans. Allan Stoekl, Minneapolis:
University of Minnesota Press, 1985, p.31.

47
G. Bachelard, *op. cit.*, p.7.

48
H. Frampton, *Circles of Confusion, op. cit.*, pp.87—106.

49
Ibid., p.98.

50
Ibid.

51
Ibid.

52
'An Evening with Hollis Frampton', 8 March 1973. SR, 70.22.
MoMA Archives NY.

53
'An Evening in Tribute to Hollis Frampton', 18 April 1985. Sound Recordings
of Museum-Related Events, 85.4. The Museum of Modern Art Archives,
New York.

54
As cited in Janine Mileaf, 'Between You and Me', *Art Journal*, Spring 2004, p.1.

55
H. Frampton, *Circles of Confusion, op. cit.*, p.59.

56
Ibid., p.61.

57
Ibid.

58
Ibid., p.68.

59
Anonymous author, http://www.7hours.com/powder/frampton.htm

60
Carl Andre and Hollis Frampton, *12 dialogues: 1962–1963*, Halifax: Press of the Nova Scotia College of Art and Design, 1981, p.90.

61
Ibid.

62
Frampton in a 1972 interview, in B. Jenkins and S. Crane, *op. cit.*, p.12.

63
Ibid., p.87.

64
S. MacDonald, *op. cit.*, pp.61–62.

65
H. Frampton, *Circles of Confusion, op. cit.*, p.10.

66
Ibid., p.105; emphasis added.

67
Ibid., p.97.

68
W. Benjamin, *The Arcades Project, op. cit.*, p.456.

69
H. Frampton, *Circles of Confusion, op. cit.*, p.100.

70
W. Benjamin, *op. cit.*, p.458.

71
Annette Michelson's term, as used in her introduction to H. Frampton, *Circles of Confusion, op. cit.*, p.15.

72
Heide Schlüpmann, *op. cit.*, p.103.

73
Siegfried Kracauer, *The Mass Ornament*, trans. Thomas Levin, Cambridge and London: Harvard University Press, 1995, p.60.

74
B. Pascal, *op. cit.*, p.116.

75
Ibid., p.25.

76
Blaise Pascal, *The Great Shorter Works of Pascal*, trans. Emeile Cailliet
and John C. Bankenagel, Philadelphia: Westminster Press, 1948, p.117.

77
H. Frampton, *Circles of Confusion, op. cit.*, p.98.

78
S. Kracauer, *op. cit.*, p.47.

79
'An Evening with Hollis Frampton', 8 March 1973. SR, 70.22.
MoMA Archives NY.

80
S. MacDonald, *op. cit.*, p.62.

81
H. Frampton, *Circles of Confusion*, *op. cit.*, p.115.

82
Ibid., p.194.

83
Sigmund Freud, 'Beyond the Pleasure Principle', in James Strachey (ed. and
trans.), *The Standard Edition of the Complete Psychological Works of Sigmund
Freud*, London: Hogarth Press, 1960–74, pp.18–31.

84
P. Dubois, *op. cit.*, p.168.

85
H. Frampton, 'A Stipulation of Terms from Maternal Hopi',
Circles of Confusion, op. cit., pp.172–73.

86
Ibid.

87
H. Frampton, 'For a Metahistory of Film', *Circles of Confusion, op. cit.*, p.111.

88
S.M. Eisenstein, *Eisenstein on Disney*, trans. Alan Upchurch, New York:
Metheun, 1988, p.33.

89
G. Bachelard, *op. cit.*, p.14.

90
S.M. Eisenstein, *op. cit.*, pp.32−33.

91
W. Benjamin, *The Arcades Project*, *op. cit.*, pp.462−63.

92
Ibid.

93
Ibid., p.464.

94
H. Frampton, *Circles of Confusion*, *op. cit.*, p.96.

95
Ibid.

96
W. Benjamin, *The Arcades Project*, *op. cit.*, pp.456.

97
H. Frampton, *Circles of Confusion*, *op. cit.*, p.97.

98
W. Benjamin, *The Arcades Project*, *op. cit.*, p.473.

99
Ibid., p.466.

100
Ibid.

101
S. MacDonald, *op. cit.*, p.61.

102
W. Benjamin, *The Arcades Project*, *op. cit.*, p.466.

103
Ibid.

104
Ibid., p.462.

105
Ibid., p.466.

106
H. Frampton, *Circles of Confusion, op. cit.*, pp.96—97.

107
W. Benjamin, *The Arcades Project, op. cit.*, pp.461—462.

108
H. Frampton, *Circles of Confusion, op. cit.*, p.113.

109
Hunter S. Thompson, *Fear and Loathing in Las Vegas* (New York: Vintage, 1971), p.202.

110
Svetlana Boym, *op. cit.*, p.xiii.

111
Ibid., pp.xiii—iv

112
S. MacDonald, *op. cit.*, p.60.

113
H.S. Thompson, *op cit.*, p.23.

114
Ibid., p.202.

115
S. MacDonald, *op. cit.*, p.60.

116
S. Boym, *op. cit.*, p.xiv.

117
Patrick Keiller, 'The city of the future', *City*, Vol.7 no.3, p.384.

118
Ibid.

119
Kathleen Stewart, 'Nostalgia — A Polemic', *Cultural Anthropology*, Vol.3 no.3, August 1988, p.228.

120
Ibid.

121
Walter Benjamin, *The Origin of German Tragic Drama*, trans. John Osborne,
London: Verso, 1977, p.178.

122
T.W. Adorno, *op. cit.*, p. 119.

123
K. Stewart, *op. cit.*, p.235.

124
Ibid.

125
Ibid.

126
Ibid.

127
'An Evening with Hollis Frampton', 8 March 1973. SR, 70.22.
MoMA Archives NY.

128
This phrase 'sentient springs' is one Benjamin uses in 'One Way Street'
to describe the warmth and subjective presence that commodified artworks
produced in the entry entitled 'This Space for Rent'. See Walter Benjamin,
Reflections, trans. Edmund Jephcott, New York: Harcourt, 1978, p.86.

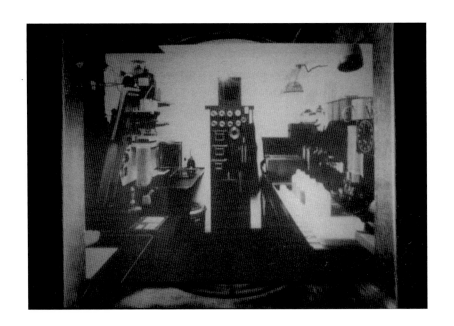

1—18. stills from *(nostalgia)*, 1971,
16mm black-and-white film

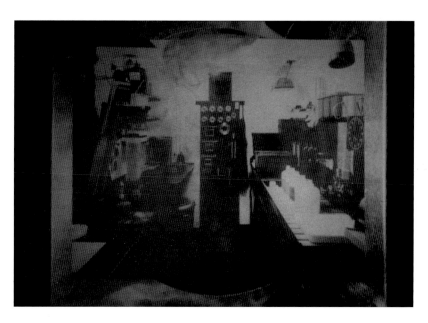

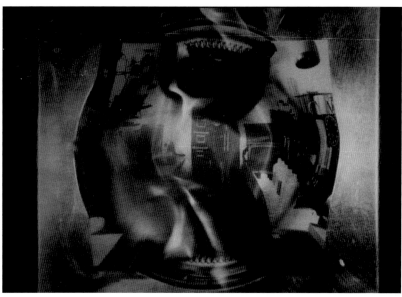

2.—3.

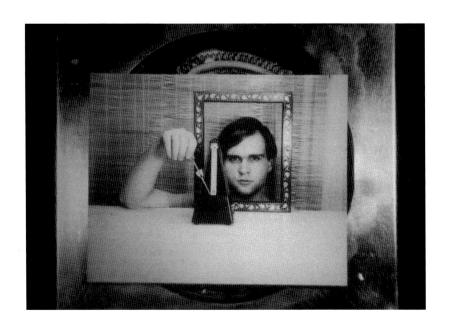

4.

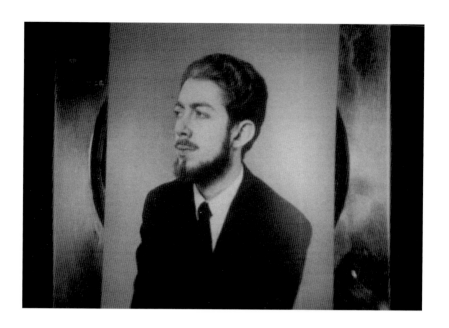

5.

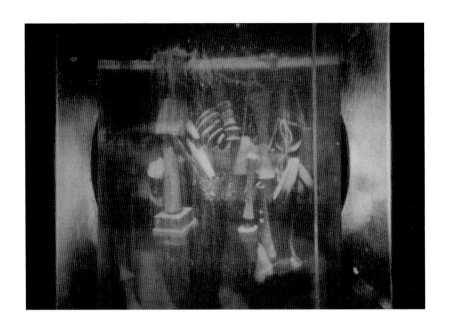

6.

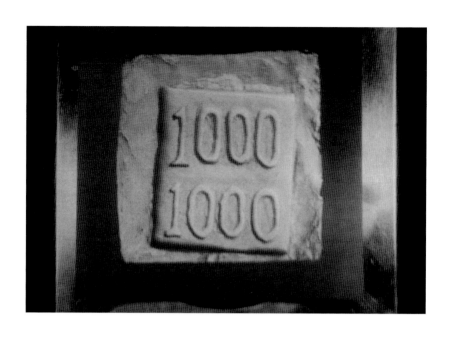

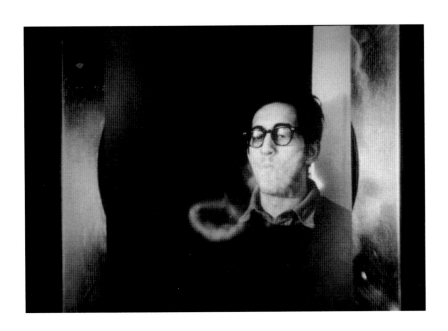

8.

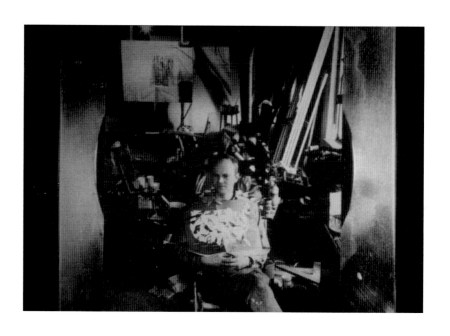

9.

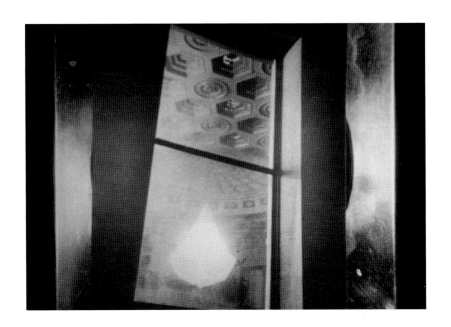

10.

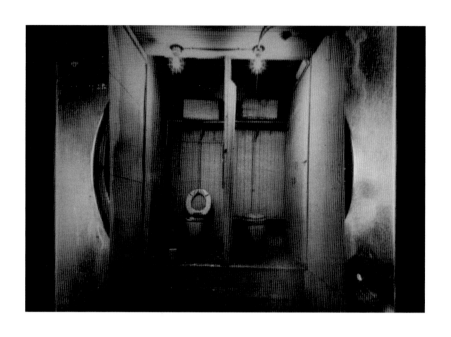

11.

12.

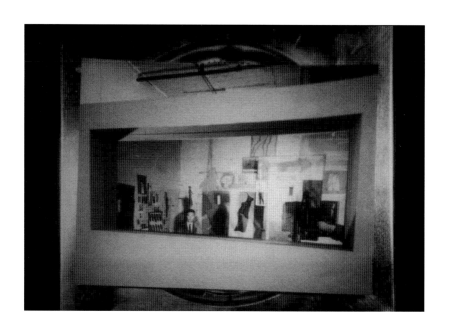

13.

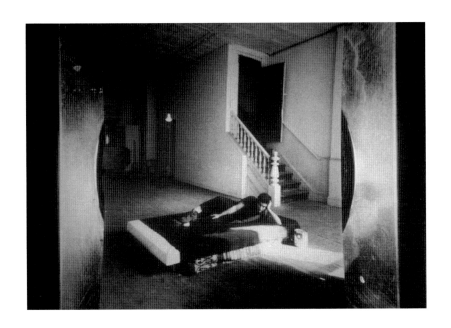

14.

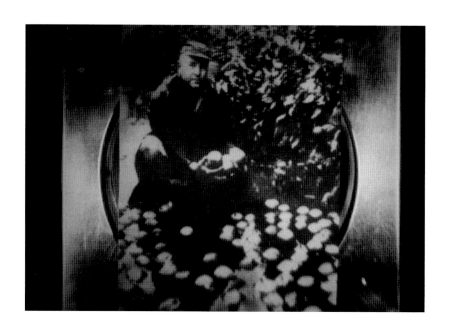

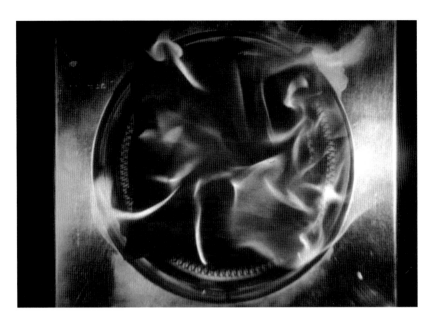

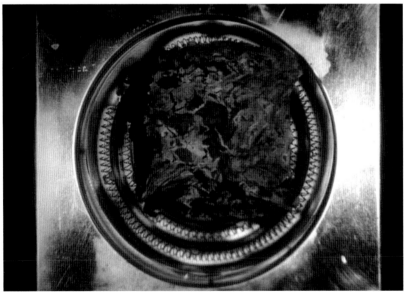

16.—17.

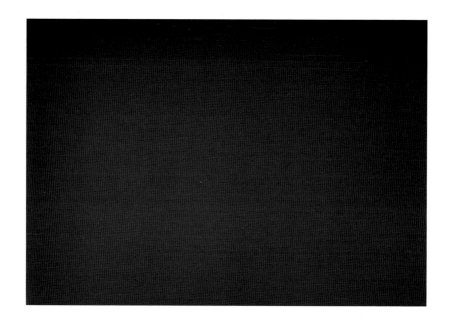

(nostalgia) Soundtrack
Blows into microphone: *Is it alright?*
Voice off mike: *It's alright.*
Pause.
Reads: *These are recollections of a dozen still photographs I made several years ago.*
Pause. Blows into microphone.
Pause. *Does it sound alright?*
Voice off mike: *Yes, yes, perfectly. It's fine.*
Pause.

Reads: *This is the first photograph I ever made with the direct intention
of making art.*
 *I had bought myself a camera for Christmas in 1958. One day early in
January of 1959, I photographed several drawings by Carl Andre, with whom
I shared a cheap apartment on Mulberry Street. One frame of film was left over,
and I suggested to Carl that he sit, or rather, squat, for a portrait. He insisted
that the photograph must incorporate a handsome small picture frame that
had been given him a year or so before by a girl named North.*
 *How the metronome entered the scheme I don't recall, but it must have
been deliberately.*
 *The picture frame re-appears in a photograph dated March 1963, but there
isn't time to show you that one now. I discarded the metronome eventually,
after tolerating its syncopation for quite a while. Carl Andre is twelve years older
and more active than he was then. I see less of him nowadays than I should
like; but then there are other people of whom I see more than I care to.*
 *I despised this photograph for several years. But I could never bring myself
to destroy a negative so incriminating.*

I made this photograph on March 11, 1959. The face is my own, or rather it was my own. As you see, I was thoroughly pleased with myself at the time, presumably for having survived to such ripeness and wisdom, since it was my twenty-third birthday.

I focused the camera, sat on a stool in front of it, and made the exposures by squeezing a rubber bulb with my right foot.

There are eleven more photographs on the roll of film, all of comparable grandeur. Some of them exhibit my features in more sensitive or imposing moods.

One exposure records what now looks to me like a leer. I sent that one to a very pretty and sensible girl on the occasion of the vernal equinox, a holiday I held in some esteem. I think I wrote her some sort of cryptic note on the back of it. I never heard from her again.

Anyhow, photography had obviously caught my fancy. This photograph was made in the studio where I worked. It belonged to the wife of a friend. I daresay they are still married, but he has not been my friend for nearly ten years. We became estranged on account of an obscure mutual embarrassment that involved a third party, and three dozen eggs.

I take some comfort in realising that my entire physical body has been replaced more than once since it made this portrait of its face. However, I understand that my central nervous system is an exception.

This photograph was made in September of 1960. The window is that of a dusty cabinetmaker's shop, on the west side of West Broadway, somewhere between Spring Street and West Houston.

I first photographed it more than a year earlier, as part of a series, but rejected it for reasons having to do with its tastefulness and illusion of deep space.

Then, in the course of two years, I made a half-dozen more negatives. Each time, I found some reason to feel dissatisfied. The negative was too flat, or too harsh; or the framing was too tight. Once a horse was reflected in the glass, although I don't recall seeing that horse. Once, I found myself reflected, and my camera and tripod.

Finally, the cabinetmaker closed up shop and moved away. I can't even remember exactly where he was anymore.

But a year after that, I happened to compare the prints I made from the six negatives. I was astonished! In the midst of my concern for the flaws in my method, the window itself had changed, from season to season, far more than my photographs had! I had thought my subject changeless, and my own sensibility pliable. But I was wrong about that.

So I chose the one photograph that pleased me most after all, and destroyed the rest. That was years ago. Now I'm sorry. I only wish you could have seen them!

In 1961, for six or eight months, I lived in a borrowed loft on Bond Street, near the Bowery.

A young painter, who lived on the floor above me, wanted to be an Old Master. He talked a great deal about gums and varnishes; he was on his way to impastos of record thickness.

The spring of that year was sunny, and I spent a month photographing junk and rubble, in imitation of action painting. My neighbour saw my new work, and he was not especially pleased.

His opinion upset me... and for good reason. He lived with a woman (I believe her father was a Brazilian economist) who seemed to stay with him out of inertia. She was monumentally fair and succulent and indifferent. In the warm weather, she went about nearly naked, and I would invent excuses to visit upstairs, in order to stare at her.

My photographs failing as an excuse, I decided to ingratiate myself in the household by making a realist work of art. I carved the numerals you see out of modelling clay, and then cast them in plaster.

The piece is called A Cast of Thousands. The numbers are reversed in the cast, of course, but I have reversed them again in printing, to enhance their intelligibility.

Anyway, I finally unveiled the piece one evening. I suppose the painter was properly horrified. But the girl, who had never said a dozen words to me, laughed, and then laughed outrageously, and then, outrageously, kissed me.

Early in 1963, Frank Stella asked me to make a portrait. He needed it for some casual business use: a show announcement, or maybe a passport. Something like that. I only recall that it needed to be done quickly. A likeness would do.

I made a dozen likenesses and he chose one. His dealer paid me for the job.

Most of those dozen faces seem resigned, or melancholy. This one amuses me because Frank looks so entirely self-possessed. I suppose blowing smoke rings admits of little feeling beyond that.

Looking at the photograph recently, it reminded me, unaccountably, of a photograph of another artist squirting water out of his mouth, which is undoubtedly art. Blowing smoke rings seems more of a craft.

Ordinarily, only opera singers make art with their mouths.

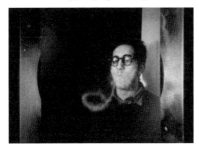

I made this photograph of James Rosenquist the first day we met. That was on Palm Sunday in 1963, when he lived in a red brick building at number 5 Coenties Slip. I went there to photograph him in his studio, for a fashion magazine. The job was a washout, but Rosenquist and I remained friends for years afterward.

He rented two floors in the building. The lower floor, where he lived with his wife Mary Lou, was cool, neat and pleasant. Mary Lou was relaxed, cool, neat, very tall and extremely pleasant. Rosenquist was calm. It was a lovely, soft, quiet Sunday.

We talked for a while and then went upstairs to his workroom. I made 96 negatives in about two hours. This was the last. It is unrelated to the others.

Rosenquist is holding open a copy of an old magazine. A map of the United States shows the distribution of our typical songbirds. I admire this photograph for its internal geometry, the expression of its subject, its virtually perfect mapping of tonal values on the grey scale. It pleases me as much as anything I did.

James Rosenquist and I live far apart now, and we seldom meet. But I cannot recall one moment spent in his company that I didn't completely enjoy.

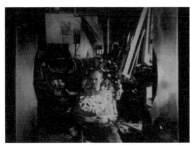

This photograph was made at about 3 o'clock on the morning of June 6, 1963, in lower Manhattan. It may even have been Wall Street.

84 | Hollis Frampton

It is seen from the sidewalk, through the window of a large bank that had been closed for renovation and partially demolished inside. A big crystal chandelier is draped in a dusty, translucent membrane that recalls the tents of caterpillars. Someone has written with a forefinger, on the dusty pane, the words 'I like my new name'.

This seemed mysterious to me. At that time, I was much taken with the photographs of Lartigue, and I wanted to make photographs as mysterious as his, without, however, attempting to comprehend his wit.

All I learned was that the two were somehow bound together. Anyway my eye for mystery is defective, and so this may be the only example I'll ever produce.

Nevertheless, because it is a very difficult negative to print, I find that I do so less and less often.

This photograph of two toilets was made in February of 1964, with a new view camera I had just got at that time.

As you can see, it is an imitation of a painted renaissance crucifixion.

The outline of the Cross is quite clear. At its foot, the closed bowl on the right represents the Blessed Virgin. On the left is St. Mary Magdalene: a bowl with its lid raised. The roll of toilet paper stands for the skull of Adam, whose sin is conventionally washed away by the blood the crucified Saviour sheds. The stairs leading up to the two booths symbolise Calvary.

I'm not completely certain of the iconographic significance of the light bulbs, but the haloes that surround them are more than suggestive.

Late in the fall of 1964, a painter friend asked me to make a photographic document of spaghetti, an image that he wanted to incorporate into a work of his own.

I set up my camera above an empty darkroom tray, opened a number 2 can of Franco-American Spaghetti, and poured it out. Then I stirred it around until I

saw a suitably random arrangement of pasta strands and finished the photograph in short order.

Then, instead of disposing of the spaghetti, I left it there, and made one photograph every day. This was the eighteenth such photograph.

The spaghetti has dried without rotting. The sauce is a kind of pink varnish on the yellow strings. The entirety is covered in attractive mature colonies of mould in three colours: black, green and white.

I continued the series until no further change appeared to be taking place: about two months altogether. The spaghetti was never entirely consumed, but the mould eventually disappeared.

This photograph was made in Michael Snow's studio, sometime in 1965. It was made into a poster announcing a show of his Walking Woman works at the Poindexter Gallery in that year.

As many as possible of the pieces are seen, by reflection or transmission, in a transparent sheet of acrylic plastic which is itself part of a piece. The result is probably confusing, but no more so than the show apparently was, since it seems to have been studiously ignored.

If you look closely, you can see Michael Snow himself, on the left, by transmission, and my camera, on the right, by reflection.

I recall that we worked half a day for two or three exposures. I believe that Snow was pleased with the photograph itself, as I was. But he disliked the poster intensely. He said I had chosen a typeface that looked like an invitation to a church social.

I regret to say that he was right. But it was too late. There was nothing to do about it. The whole business still troubles me. I wish I could apologise to him.

This posed photograph of Larry Poons reclining on his bed was made early in 1966, for Vogue magazine.

I was ecstatically happy that afternoon, for entirely personal reasons. I set up my camera quickly, made a single exposure, and left.

Later on, I was sent a cheque for the photograph that I thought inadequate by half. I returned it to the magazine with a letter of explanation. They sent me another cheque for the amount I asked for: $75.

Months later, the photograph was published. I was working in a colour-film laboratory at the time. My boss saw the photograph, and I nearly lost my job.

I decided to stop doing this sort of thing.

I did not make this photograph, nor do I know who did. Nor can I recall precisely when it was made. It was printed in a newspaper, so I suppose that any patient person with an interest in this sort of thing could satisfy himself entirely as to its origins.

The image is slightly indistinct. A stubby, middle-aged man wearing a baseball cap looks back in matter-of-fact dismay or disgruntlement at the camera. It has caught him in the midst of a display of spheres, each about the size of a grapefruit, and of some nondescript light colour. He holds four of them in his cupped hands. The rest seem half-submerged in water, or else lying in something like mud. A vague, mottled mass behind the crouching man suggests foliage.

I am as puzzled and mildly distressed by the sight of this photograph as its protagonist seems to be with the spheres. They seem absolutely alien, and yet not very forbidding, after all.

What does it mean?

I am uncertain, but perfectly willing to offer a plausible explanation. The man is a Texas fruit-grower. His orchards lie near the Gulf of Mexico. The spheres are grapefruit. As they neared maturity, a hurricane flooded the orchard and knocked down the fruit. The man is stunned by his commercial loss, and a little resentful of the photographer who intrudes upon his attempt to assess it.

On the other hand, were photography of greater antiquity, then this image might date from the time of, let us say, Pascal; and I suppose he would have understood it quite differently.

Since 1966 I have made few photographs. This has been partly through design and partly through laziness. I think I expose fewer than fifty negatives a year now. Of course I work more deliberately than I once did, and that counts for something. But I must confess that I have largely given up still photography.

So it is all the more surprising that I felt again, a few weeks ago, a vagrant urge that would have seemed familiar a few years ago: the urge to take my camera out of doors and make a photograph. It was a quite simple, obtrusive need. So I obeyed it.

I wandered around for hours, unsatisfied, and finally turned towards home in the afternoon. Half a block from my front door, the receding perspective of an alley caught my eye … a dark tunnel with the cross-street beyond brightly lit. As I focused and composed the image, a truck turned into the alley. The driver stopped, got out, and walked away. He left his cab door open.

My composition was spoiled, but I felt a perverse impulse to make the exposure anyway. I did so, and then went home to develop my single negative.

When I came to print the negative, an odd thing struck my eye. Something, standing in the cross-street and invisible to me, was reflected in a factory window, and then reflected once more in the rear-view mirror attached to the truck door. It was only a tiny detail.

Since then, I have enlarged this small section of my negative enormously. The grain of the film all but obliterates the features of the image. It is obscure; by any possible reckoning, it is hopelessly ambiguous.

Nevertheless, what I believe I see recorded, in that speck of film, fills me with such fear, such utter dread and loathing, that I think I shall never dare to make another photograph again.

Here it is!
Look at it!
Do you see what I see?